DONCASTER
THROUGH TIME
Peter Tuffrey

AMBERLEY

Acknowledgements

I am grateful for the assistance received from the following people: Peter Jary, Hugh Parkin and Derek Porter. Gratitude should also be expressed to my son Tristram Tuffrey for his general help and support.

First published 2016

Amberley Publishing
The Hill, Stroud, Gloucestershire, GL5 4EP
www.amberley-books.com

Copyright © Peter Tuffrey, 2016

The right of Peter Tuffrey to be identified as the Author of this work has been asserted in accordance with the Copyrights, Designs and Patents Act 1988.

ISBN 978 1 4456 5452 2 (print)
ISBN 978 1 4456 5453 9 (ebook)

British Library Cataloguing in Publication Data.
A catalogue record for this book is available from the British Library.

Typesetting by Amberley Publishing.
Printed in Great Britain.

Introduction

Doncaster saw significant changes to the townscape from the early nineteenth century, with much building taking place beyond the confines of the bar-dyke. This was predominately across gardens and fields, resulting in the creation of a number of new streets, such as: Cartwright Street, Spring Gardens, Wood Street and Duke Street. House-building also began along Waterdale, one of the main east-west routes negotiating the town. Impressive properties began to grace the main thoroughfares on South Parade, Hall Gate, French Gate and High Street; all of which were situated on the Great North Road that cut through the centre of the town. Doncaster's inns and hotels all benefitted from the coaching trade, for example: the Reindeer, Ram and Angel.

The numerous alterations made to the town are particularly evident when comparing the maps from 1767 and 1828. During this period, Doncaster was a quiet market town; trade was mainly centred round the market place, which dates back to the medieval period. It was also noted for its racecourse, which annually staged the St Leger. Major growth was brought about when the Great Northern Railway extended its main-line through Doncaster in 1848, also with the removal of its engine, carriage, and wagon works from Boston to the town in 1853. As a result, house and commercial property-building extended beyond earlier developments. Hyde Park and Hexthorpe also emerged as a place for railway men to settle when they arrived from many different parts of the country. The OS map of 1852 is demonstrative of the significant growth in the area compared to the one from 1828.

Other related industries grew up alongside GNR's works, they encouraged the town to improve its existing facilities and helped to introduce new ones; for example, a hospital was established, new market buildings constructed, and the streets were lit by gas.

After the introduction of public health acts towards the end of the nineteenth century, Doncaster Corporation embarked on street widening schemes. An example of this can be seen in Baxter Gate, which is illustrated within this book; it is interesting to see how far back the street line was set. The work was carried out to adhere to public health legislation, but also in anticipation of running of electric trams along streets that were deemed too narrow to ensure pedestrian safety. Over time, widening was also carried out in: Sunny Bar, St Sepulchre Gate, Silver Street, Scot Lane, and Cleveland Street.

The latter half of the nineteenth century saw the creation of one of Doncaster's former architectural showpieces, Station Road; it wound from the railway station to the town centre and was adorned with magnificent buildings. Between this period and the early twentieth century, Doncaster became endowed with many impressive buildings for housing, commerce and public use: all designed by a small group of architects, often reflecting style and unquestionable competence in their work.

As further government acts were introduced in the immediate post-war years, Doncaster Corporation was faced with a number of problems. For example, the 1951 Development Plan created zones for a number of activities; also, the town centre was designated a commercial and business area, resulting in houses being demolished. A large batch of these included those in the areas bounded by Young Street, Waterdale, Spring Gardens and Cleveland Street. In their place sprung the Golden Acres Development, now Waterdale Shopping Centre.

The 1960s saw many towns building shopping centres, Doncaster was no exception. The Arndale (now known as Frenchgate) was constructed between 1960 and 1971; in so doing, it swallowed a vast area bounded by French Gate, St Sepulchre Gate, Station Road and Trafford Street. Sadly, this cleared a number of once familiar and popular buildings, most notably those in Station Road, with the exception of the Grand Theatre. Running concurrent with these schemes was the construction of new roads to ease considerable traffic congestion. Since Doncaster was situated on one of the country's major crossroads, drastic measures needed to be adopted. One of the schemes involved cutting a road past St George's church, marooning the building from the natural route to and from the town centre. Among the other roads built at this time were the Inner Relief Road and the Southern Relief Road.

By the mid-1970s the remodelling of the town centre had reached a plateau (whether or not this was to the liking of residents is another matter; there has certainly been heated debates on a number of issues). However, the alterations continued in the subsequent years, right up to the present day. The Colonnades, completed around 1984, created a small shopping complex by taking in an area bounded by Pell's Close, parts of Duke Street, and Cleveland Street. In 2006 the Frenchgate Centre was extended and a transport interchange was incorporated. Unfortunately, this colossal development has tended to take shoppers away from the more traditional areas such as Market Place, Waterdale, Silver Street and Hall Gate. Some entrepreneurs have believed the only way to breathe new life into these areas has been to establish pubs, bars and restaurants in them; but this, as might be expected, is not to everyone's liking.

Other new improvements include the building of St George's Bridge and making a number of streets pedestrian friendly. In addition, recent years have seen the Civic Quarter's completion in the Waterdale area; a project that began in the late 1950s. Further changes include: the Doncaster Technical College was demolished and its facilities transferred to the Hub; the council house was replaced with a new building for the authority's various departments; and Glasgow Paddocks car park was cleared for the erection of a new dedicated theatre (Cast).

Former Doncaster Civic Trust secretary, the late Eric Braim, did much to influence planning matters across the Doncaster area; the completion of the Civic Quarter was one of his long standing campaigns. We often spoke about creating a book such as the one you are currently reading; hopefully it encompasses many of the changes that have occurred over the last century, and more. Thus, readers now have the opportunity to judge for themselves how Doncaster Central has progressed, for better or worse, through time.

Baxter Gate

Looking west towards the junction with Clock Corner, the north side of Baxter Gate can be seen. Widening of the thoroughfare by the Doncaster Corporation took place during the early 1890s. One of the beneficial results of the development was that it allowed electric trams, travelling to either Becket Road or Avenue Road, to move comfortably down the route when it was introduced in 1903. Trolleybuses also used Baxter Gate until 1963 but, thankfully, it is no longer on a public transport route. The *Doncaster Chronicle* of 11 April 1935 said the premises of printer and stationer, Elaph Bisat (seen to the right of the above image), were rebuilt on the set-back street-line without him requesting 'a penny compensation from the Corporation'.

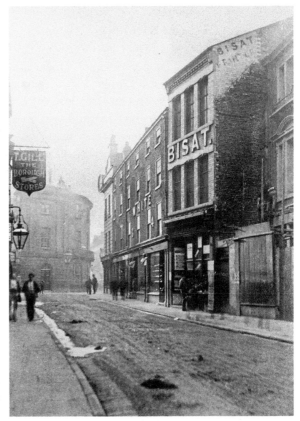

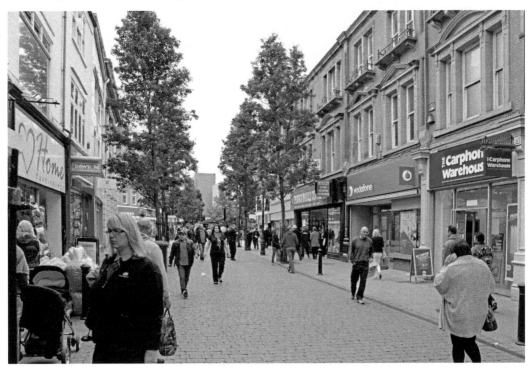

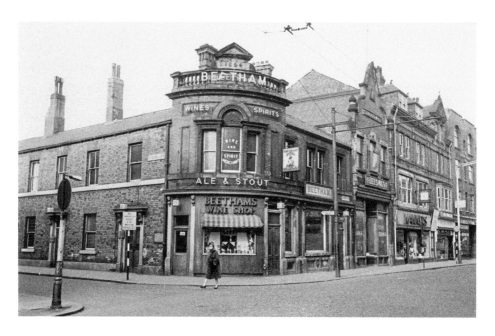

Baxter Gate/St George Gate Corner

The name of Beetham's was synonymous with the Baxter Gate/St George Gate corner from around 1826. This was when Joshua Beetham merged his George & Dragon Vaults (in St George Gate) with a wine and spirits business on the St George Gate/Baxter Gate corner. Thereafter, the corner premises were seemingly known as either Beetham's or the George & Dragon Vaults. Other members of the Beetham family also entered the business and the premises were rebuilt in the early 1890s and 1960s. The Beetham family sold out to Richard Whitaker & Son in 1945 and the pub was eventually taken over by Whitbread, who changed the name to the Gatehouse in 1986. The site is presently unoccupied and is another longstanding pub name to be wiped from the townscape.

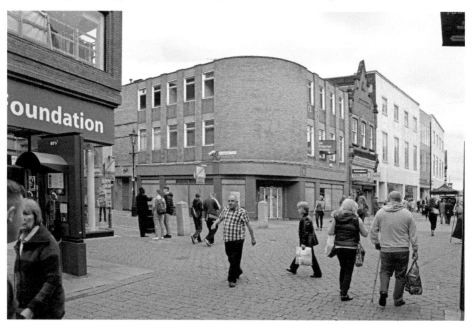

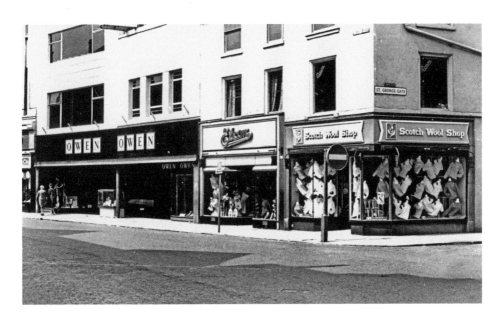

Baxter Gate/St George Gate Corner

The Liverpool firm, Owen Owen Ltd (established in 1865), bought the store Verity & Sons Ltd in October 1950. Mr and Mrs G. E. Verity of Pudsey had opened the Baxter Gate premises in October 1911, having acquired the business of Armstrong & Co.; their store was damaged and rebuilt following a fire in 1938. Owen Owen Ltd had branches at Liverpool, Preston, Blackpool and Coventry; they were a similar kind of firm to Verity's, specialising in drapery. Extensive alterations were carried out by Owen Owen Ltd in 1966 to Nos 13 and 14 Baxter Gate, they also added an extension in St George Gate. Owen Owen Ltd sold the business to the House of Fraser Group in 1975, establishing a Binns department store. The premises currently trade as House of Fraser (the change of name occurred in 2009).

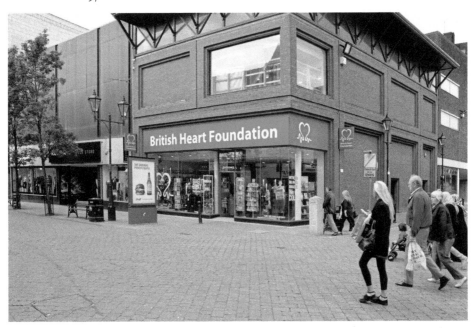

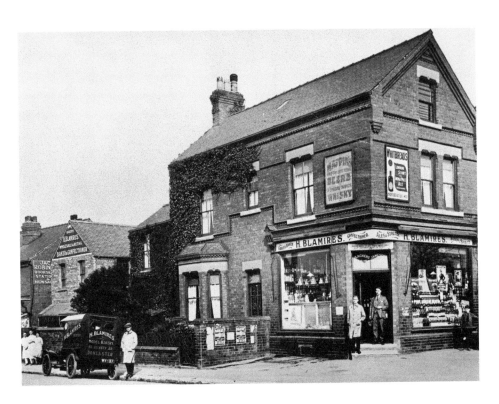

Beckett Road

Blamires' wine and spirits business was established at the Beckett Road/Jubliee Road corner (*c.* 1920) by Herbert Blamires; he opened other shops in Doncaster, Barnsley, Sheffield and Rotherham. Herbert died in 1956 and the Beckett Road shop was continued by his son, Robert, and daughter-in-law, Brenda. They managed the shop together until Robert died in December 1972; Brenda struggled on alone until she retired six years later. Blamires' shop was unique as it was situated in an area of mixed social classes, which ranged from railway and factory workers in Jubilee, Stanhope and Morley Roads, to professional people in Avenue, St May's and Auckland roads. The premises currently cater for an Eastern European community, but this also provides an opportunity for others to sample the goods on offer.

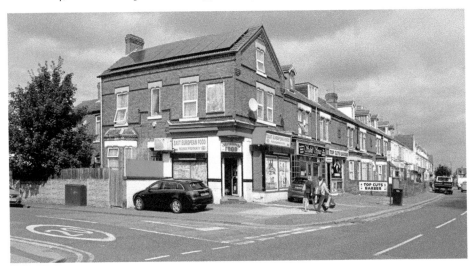

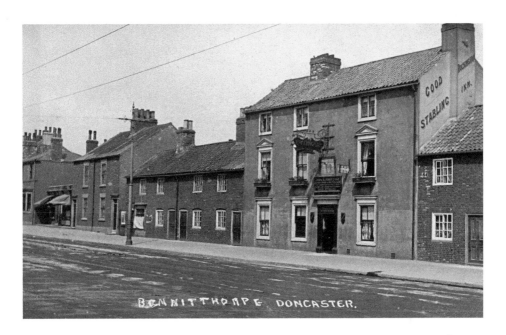

BENNITTHORPE DONCASTER.

Bennethorpe, Rockingham

The original Rockingham Hotel (seen above) was built in 1778 by William Bennett – the first licensee of the premises – who also erected other property in Bennetthorpe. The name is perhaps derived from Lord Rockingham, a founder of Doncaster's famous horse race, St Leger. The hotel was rebuilt to the designs of Allen and Hickson in the English Renaissance style during 1926. Often described as a pub near the gateway to the town, the Rockingham was also a favourite of Doncaster Rovers' fans when the team played at Belle Vue. The pub closed around 2012 and despite protests from residents to Doncaster Council's planning committee, it was eventually converted to flats. The building is presently known as Rockingham House.

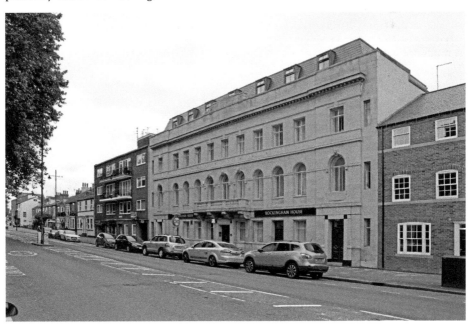

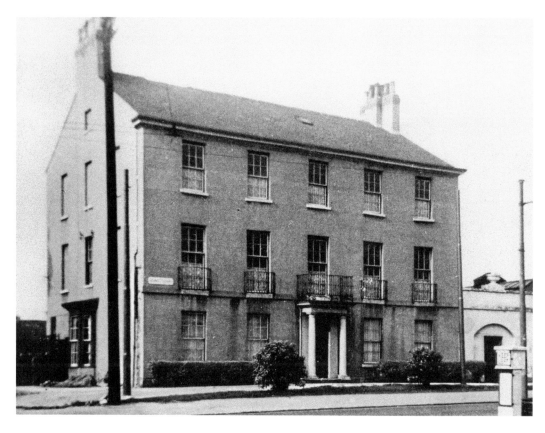

Bennethorpe Belle Vue House/Grand St Leger Hotel

Bell Vue House (built in 1810) was intended to be used as a hotel under the title of the 'Turf', but became a private residence until the 1850s when it was converted into a depot by the West Yorks Light Infantry. For a short time in the late 1890s it once again became a private residence, but subsequently was used to house officials attending the Doncaster Races. In 1984 the premises were extensively altered, and reopened as the Grand St Leger Hotel.

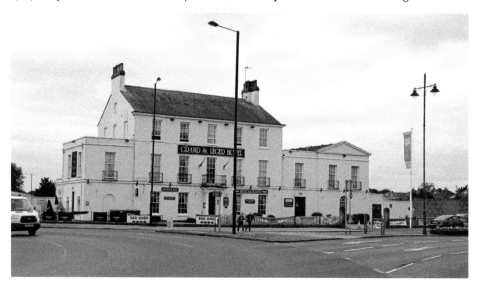

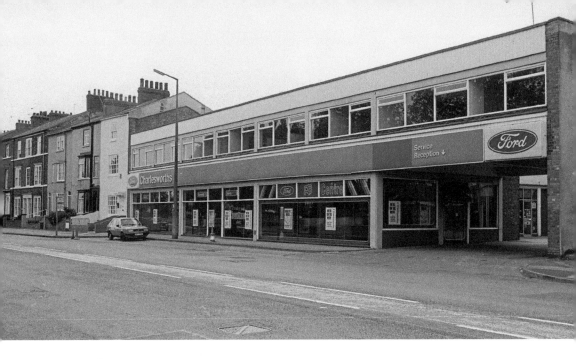

Bennetthorpe

The top picture shows the motor car showroom of E. & G. Charlesworth shortly before the site underwent massive redevelopment. The firm was first established by Edgar Charlesworth during 1913 in Wombwell, he was later joined by his father, George, and in 1915 the company was styled E. & G. Charlesworth. They moved to Bennetthorpe in 1926. Subsequent family members ran the business and the Bennetthorpe site was modernised in 1963. In 1990, the company celebrated its 75th anniversary with a major move to a new showroom at Barnby Dun Road. Following clearance of the site, the vacant area was redeveloped to include premises perhaps more in-keeping with the general character of Bennetthorpe and the adjacent properties.

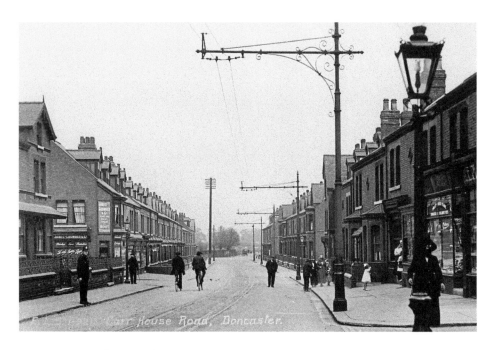

Carr House Road

Looking east is the stretch of Carr House Road between Elmfied Road and Chequer Road. An 1852 Ordnance Survey map shows Carr House Lane (a bridle road) extending from Green Dyke Lane to the racecourse. A short spur on Carr House Lane's south-eastern side once led to Carr House and its estate, presumably the reason that the route is thus named. Later, the route's western end was built upon, becoming the main focus of a railway community that grew following the establishment and development of the Great Northern Railway's locomotive, carriage and wagon building and repair works. A bottle neck on this older section of Carr House Road was created with the post-war motorised traffic boom, particularly when vehicles were parked or making deliveries. Thus, the properties on the south side were demolished to ease the traffic flow.

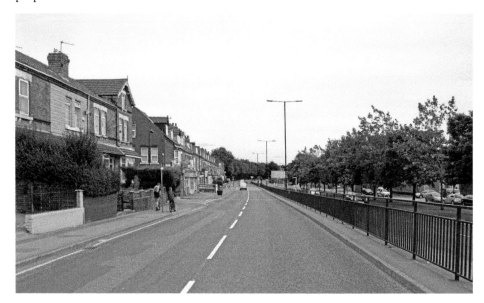

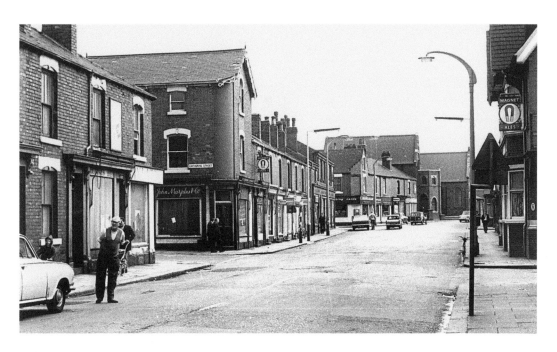

Carr House Road

Above, facing east, is a section of Carr House Road, extending between Catherine Street and to a point just beyond Jarratt Street. A widened section further east was opened to the race course in the 1920s. To the far right, at the side of the Prince of Wales public house, is Nelson Street. Many of the properties on both sides of the street (including the pub), were demolished to make room for the construction of the Southern Relief Road during the early 1970s. The upsurge in motorised traffic that travelled from the east side of the town to join the A1 (which opened in 1961) made it imperative to construct a dual carriageway on the entire length of Carr House Road. The M18 was later to ease the east–west flow of traffic and a feeder route was extended from Carr House Road.

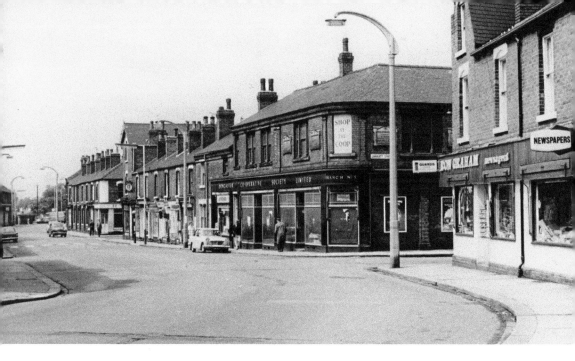

Carr House Road

The top picture is from the 1960s and it shows Carr House Road looking west towards the cemetery from just beyond Jarratt Street. One of the main focuses here was the Doncaster Co-operative Society's branch No. 5 at the Carr House Road/Jarratt Street corner. The building's foundation stone was laid on 22 October 1887 and several hundred people assembled to witness the ceremony. Built by a local firm, Messrs Arnold & Son, the premises consisted of grocery and provision, hardware, and butchery stores. The building fell shortly after the picture was taken, along with many others beyond it and on the opposite side of the road. Ron Graham, owner of the local newsagents was a well-known occupant of the premises on the right until his death in 2007.

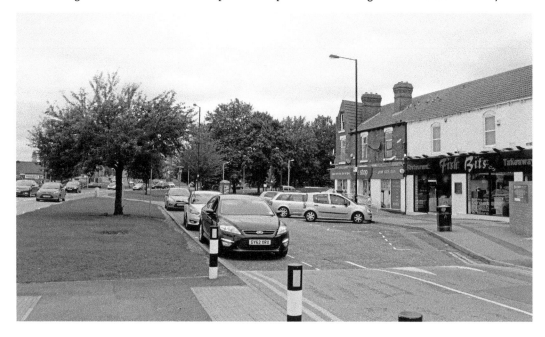

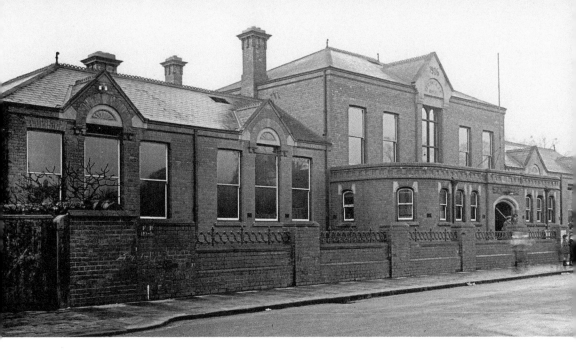

Chequer Road

Opened in 1906 by Mayor George Smith, the Boys Elementary School was demolished in 2009, along with the Beechfield School (Girls and Infants). Early in 2013, planning permission was granted to Muse Developments Ltd for ninety-seven residential dwellings designed by architects Brewster Bye, whose website states that the unique development forms a mix of one, two and three bedroom houses. It goes on to explain, 'Our intention was to continue the strong pattern of terraces and provide a contemporary interpretation of the terraced and back to back house.' Muse Developments claim that the mini housing estate, the Gables, is the first new housing scheme in the town for a number of years and it forms a key element of Doncaster's new £300 million civic and cultural quarter.

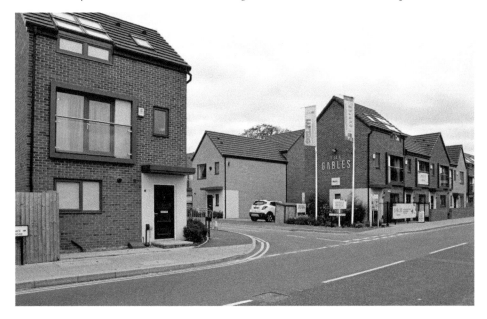

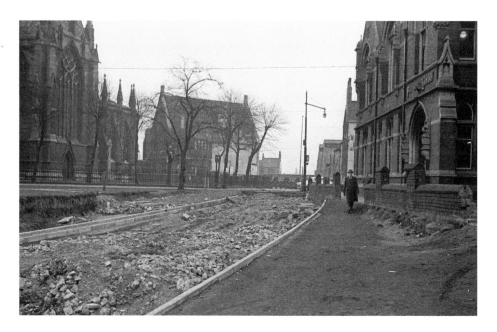

Church Way

Church Way (also known as East Bypass) extends from French Gate to Wheatley Lane. To most local people it is unforgiveable that the road has isolated St George's church from the town centre and caused the demolition of many noted buildings. The perceived need for the road can be traced back to at least the 1930s when the borough surveyor was asked to provide proposals for the intended route. The scheme did not gain momentum until the Doncaster Corporation published a development plan for the town in 1951, in accordance with the 1947 Town and Country Planning Act. The plan revealed that the Great North Road and the Sheffield–Grimsby trunk road, which intersected in the centre of Doncaster, were inadequate to cope with the increasing volume of traffic that passed through the town each day. The picture above shows work on construction of the first carriageway.

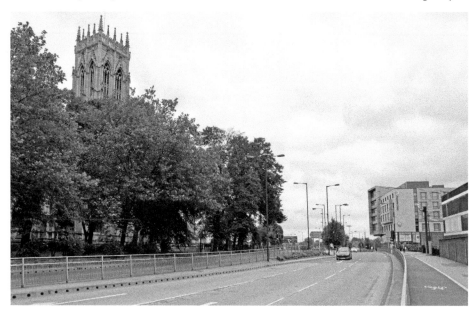

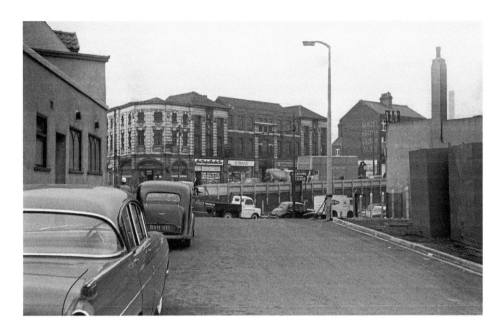

Church Way

The first phase of the road carrying single-line traffic was completed during the early 1960s. Some of the buildings that were demolished to make way for it include part of St George's National School and two popular public houses, the Black Boy and Greyhound. A number of graves in St George's churchyard also had to be removed. Financial difficulties delayed implementation of the second phase until the early 1970s. This caused problems not only for motorists, but also for pedestrians who had to negotiate the busy traffic until the subways provided in the scheme were constructed. When work did begin, the existing road was widened to become a dual carriageway. The architectural merit of buildings situated along the route was considered beforehand, but had to be sacrificed to the broader planning interests. The top picture shows the 'French Gate' end of the east bypass with the old Trades Club in the distance.

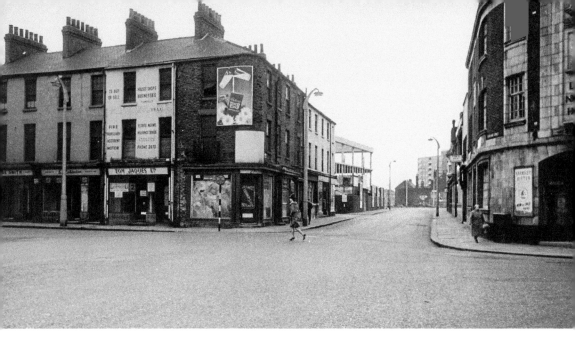

Cleveland Street

Some locals may remember a time when several buses (entering the town from the west) travelled along Cleveland Street as far as Young Street (seen left in the top picture). They then dropped a few passengers off at the Cleveland Street corner, then passed through to the Waterdale bus station. This, of course, ended when Young Street was curtailed and the new southern bus station opened. In the above image, houses at the north end of Young Street are depicted before demolition; work can also be seen on the Golden Acres site. The Lord Nelson pub (top-right) had existed on the site from at least 1870; it was rebuilt in 1934 for the widening of Cleveland Street, but has since lost its name.

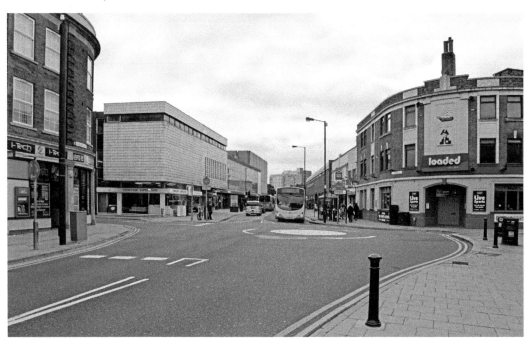

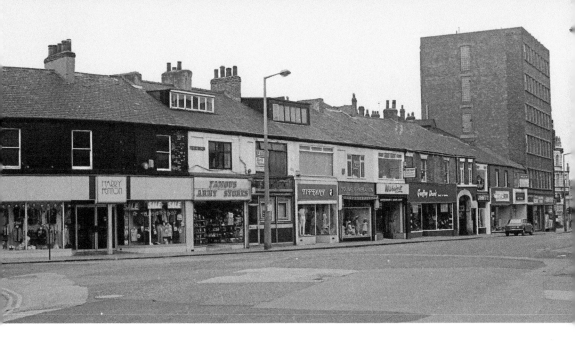

Cleveland Street, King Charles Terrace

In the *Doncaster Civic Trust Newsletter* (No. 67, May 1992), Eric Braim wrote that the row of properties above were initially houses that were first built on part of a garden in 1842. Since the garden contained a pear tree that was allegedly planted by King Charles, the name King Charles Terrace was adopted. Concern was expressed in the aforementioned newsletter regarding a potential new development, that would have resulted in the demolition of the properties and the loss of a rounded corner at the Cleveland Street/ Printing Office junction. However, when a scheme was eventually realised a number of years later, a rounded corner was included near the junction in addition to other features such as sliding sash windows and *voussoirs*. The name, Old Angel, was adopted for the new licensed premises along the former terrace; in some ways it recalls the old French Gate pub, Angel & Royal, demolished in the early 1960s.

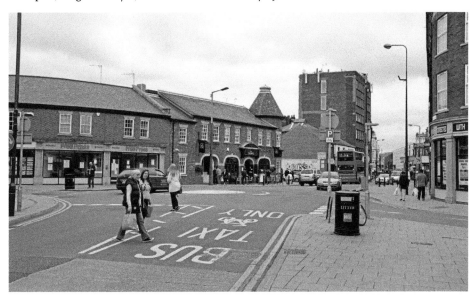

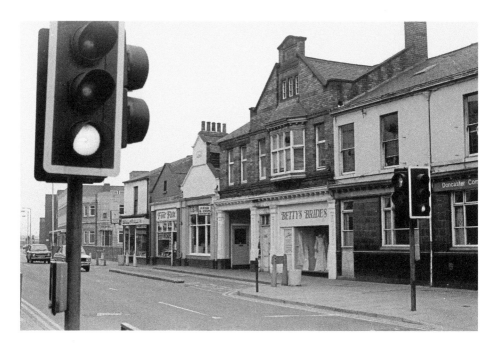

Cleveland Street

Cleveland Street was officially named by the Doncaster town clerk, Frederick Fisher Esq., on 1 August 1831 in honour of William Henry Vane (then the Marquis of Cleveland, later to be Duke in 1833). The street saw continued development throughout the post-war years. In the top picture (c. 1980), the stretch of property on the right was formerly occupied by the Old Exchange Brewery and Tavern. Plans were passed for rebuilding the brewery and adding a new frontage to the tavern in 1867 and 1909 respectively. The tavern's licence was refused around 1939 and the area was converted into offices during 1946 by the Doncaster Corporation. The former tavern was demolished during the Colonnades development c. 1982, along with the adjacent premises, including: Betty's Brides, a fish and chip shop; Feet First; and Doncaster Sales & Exchange (run by Mac Hunter).

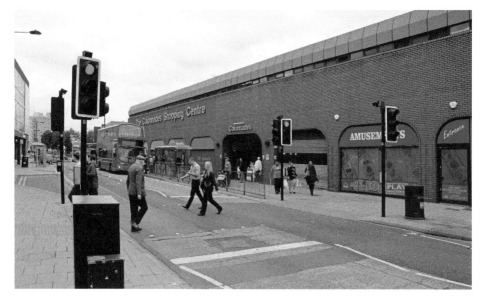

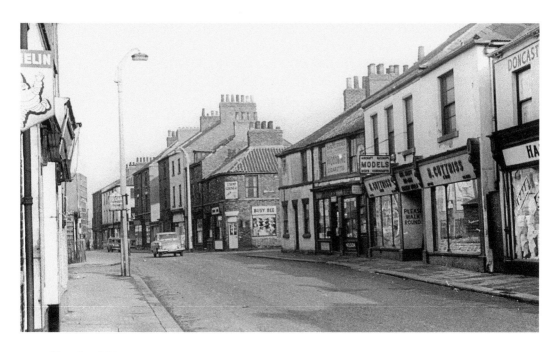

Cleveland Street

The only building that remains from the photograph above is the Danum Hotel, seen far in the distance to the left. Everything else was demolished on the street's southern side during the early 1960s for the Golden Acres development, including Cuttriss' first model shop, the Busy Bee/Stamp Corner at the junction with Baker Street and all of the properties up to Cartwright Street, continuing beyond to Young Street. The scheme forced many residents, shopkeepers and business people to find alternative accommodation. Plans for the site were put forward by Yorktown Investments Ltd, an associate company of the Equitable Debenture and Assets Corporation Ltd. There was a commemorative stone laying ceremony in April 1964. More ambitious proposals included in the project were not carried out due to the economic climate at the time. The area has since become known as the Waterdale Shopping Centre.

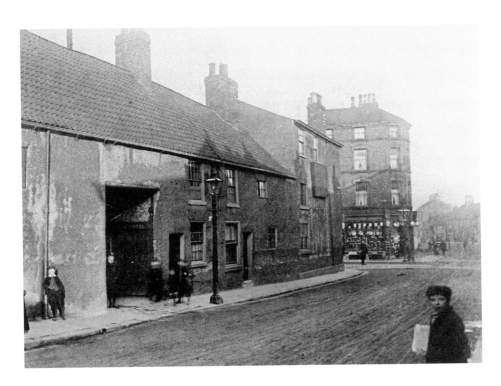

Cleveland Street

The top picture was commissioned in around 1904 by the Doncaster Corporation as a record to show the narrow eastern end of Cleveland Street, at the High Street junction. The premises dominating much of the picture belong to the Ram Inn, which had existed from at least 1793. Having purchased the pub and set-back the street-line (as part of its street widening programme), the Corporation put up the remaining land for sale; the Danum Hotel was eventually built here by W. Thornton to the designs of H. Wagstaffe in 1909. On the far right is a view of the original Silver Street, widened around 1908.

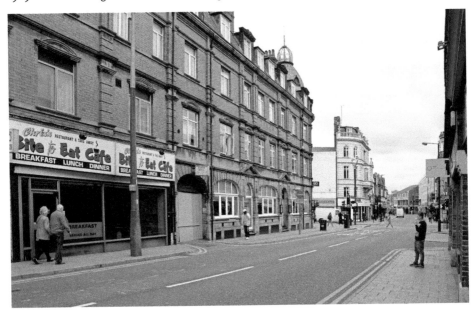

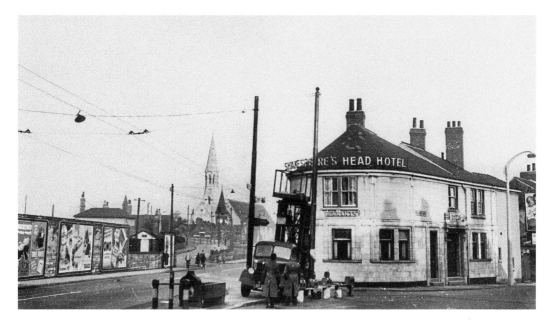

Cleveland Street/St James Street Junction

One of the 'survivors' from the above photograph is the church of St James, built in 1858 to cater for the spiritual needs of a quickly growing population, caused by the Great Northern Railway's development in the town. Prior to this, the site was occupied by a leper hospital and chapel. The adjacent St James schools were opened in 1854, they were then rebuilt in 1897 after a fire, and were eventually demolished around 1990. Trolley buses ran past the area on their way to Balby between 1931 and 1963. The last pints were pulled at the Shakespeare's Head (established in around 1833) on 19 August 1965, by landlord and landlady Mr and Mrs G. A. Wombwell. After this, the vacant site was absorbed into the construction of the Cleveland Street dual carriageway. The stretch of road from St James' church to Balby Bridge was renamed Cleveland Street in 1967.

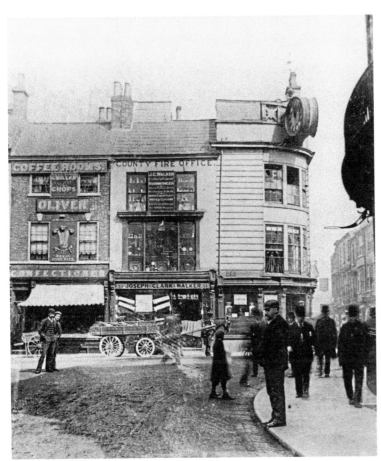

Clock Corner

Doncaster Corporation's scheme for widening Baxter Gate in the early 1890s involved the demolition of Clock Corner at the street's junction with French Gate. The clock that can be seen above was built during 1838. Architect, J. G. Walker, was responsible for designing premises on the set-back Baxter Gate street line, including the clock tower seen below. The work was carried out around 1894 and the old clock was transferred to Sunny Bar. During its lifetime, Clock Corner has survived several threats of demolition.

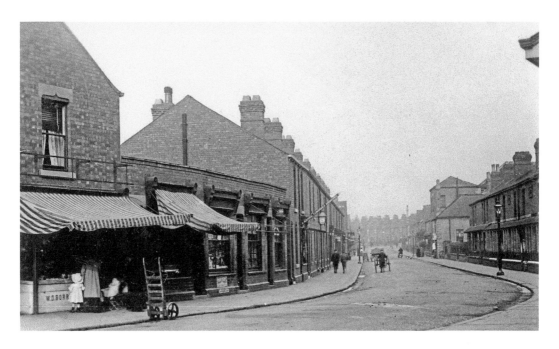

Copley Road

According to the Plans Register in the Doncaster Archives Department, proposals were submitted between February 1884 and December 1885 to build terraced houses along the new Copley Road by B. Wortley and H. Arnold & Son. Wortley sought permission to build ten more houses during 1891; proposals to build new houses and commercial properties continued up to the turn of the century, and beyond, until a small community had formed. During the latter years of the twentieth century Copley Road, along with the adjacent areas, acquired an unsavoury reputation, particularly at night. However, as a result of a concerted community effort, Copley Road has shrugged off its past and emerged with renovated properties, specialised shops and restaurants along its thoroughfare.

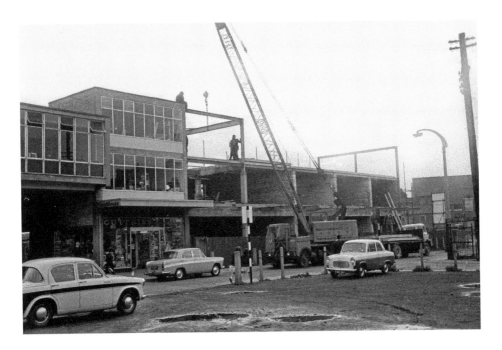

Duke Street

Laid out during the first decade of the nineteenth century, Duke Street was later to have some of the town's most unfavourable housing; following the Housing Acts of 1930 and 1935, properties in the area were cleared. The top picture illustrates redevelopment that took place on the west side during the mid-1960s. This occurred after the street had been empty and unused for several decades. One notable business to the new-look thoroughfare was Cuttriss' model shop, which had relocated in 1964 from a position only a few yards away in Cleveland Street. Once an immensely popular store, it survived until November 1983. Redevelopment on the street's east side did not occur until the early 1980s, when the construction of the Colonnades commenced.

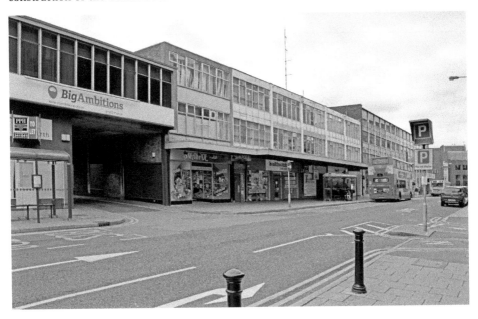

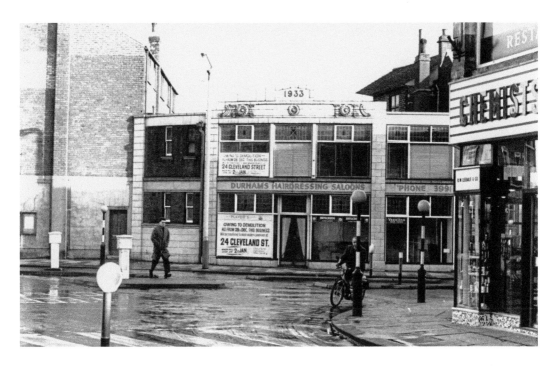

East Laith Gate

Work on widening the entrance to East Laith Gate from Sunny Bar began in the 1920s. The building in the top picture to the east side (occupied by Durham's Hairdressing Salon), was completed in 1933. On the western side, the Britannia Inn was demolished and the licence removed to Balby. The shop tenanted by the chemist R. W. Leedale & Co. was built on land not required in the widening scheme. Durham's premises can be seen before demolition and the further redevelopment in 1967, after this the business announced a transferral to Cleveland Street. For many years the rebuilt commercial premises were occupied by Derek Evans' Artist's Materials and Office Equipment store.

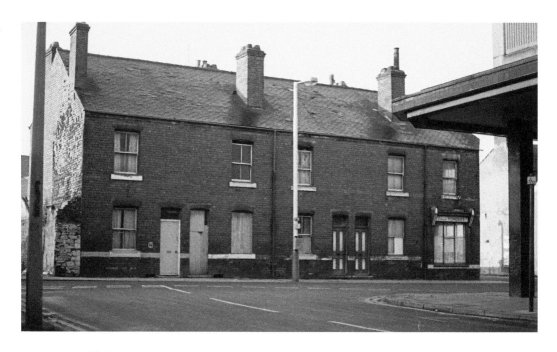

East Laith Gate

Although the East Laith Gate name may be traced to at least 1456 when it appears on a Doncaster Court Roll, the first snapshot of the type of inhabitants living there is provided by the 1841 census. There were approximately thirty-six households, with 171 occupants. The head of households in the area held a varied mix of occupations, including: labourer, hairdresser, stonemason, and veterinary surgeon. Redevelopment works and schemes during the last quarter of the twentieth century resulted in the street losing its last residential properties. The row of houses and fish & chip in the above image, taken just before demolition, illustrate this point. New commercial properties erected during the late 1980s show a return to more traditional building materials, and make a welcome relief to the overbearing large 1960s structures on some parts of the road.

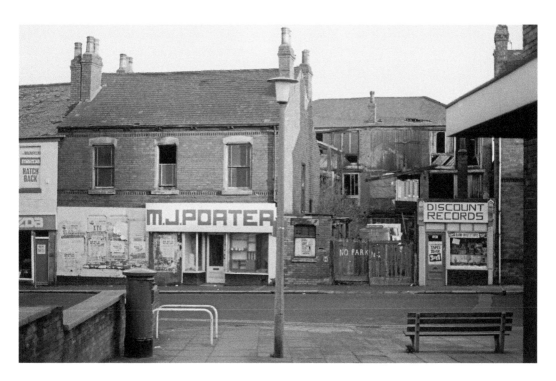

East Laith Gate

Pictured here is a section of East Laith Gate's eastern side. An OS map from 1852 shows that only half of this side of the street was built upon, this was in contrast to the western side, which was entirely occupied. Towards the end of the nineteenth century, more houses were constructed and Park Road was developed. The above picture was taken in the 1980s when the properties were empty and clearance was about to take place; before this occurred small businesses such as Discount Records enjoyed trading there for a short period. Nobody at this time would foresee that vinyl records would vanish from the music scene and be superseded by CDs, only to enjoy a welcome return once more.

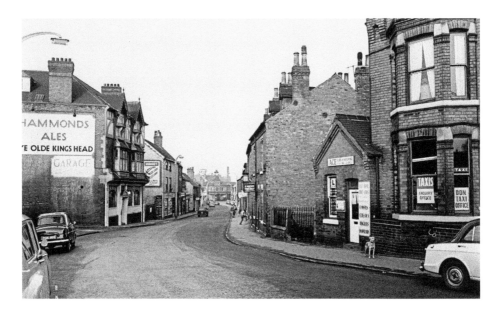

East Laith Gate

The above picture, taken around 1960, shows the street looking northwards with The Olde King's Head visible to the left advertising Hammonds' ales. This was one of three pubs that formerly traded on the street; the two others being the Britannia and Coach & Horses. The Britannia was closed in the 1920s as a result of street-widening, although (at the time of writing) the Coach and Horses still exists today. The Olde King's Head dates from 1794/95; it was rebuilt in 1895 before being demolished around 1965 for the construction of several small shop units. A large shopping precinct was built around the same time at the northern end of the street and incorporated a bowling alley; later converted to a bingo hall. The King's Head license was transferred to new premises and reopened in Bradford Row during 1965. Although initially renamed Silver Link, the old King's Head name was adopted for a time from 1973. Noticeable in the picture below, is the widened street line after the removal of properties at East Laith Gate's southern end.

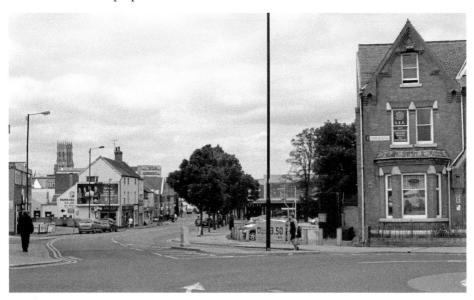

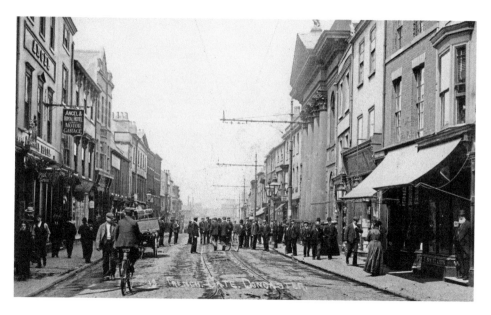

French Gate

The view in these pictures faces north. The image above was taken before 1910 when the North Bridge replaced the Marshgate level crossing, just visible in the distance. From 1902 onwards trams used to use French Gate, travelling from Greyfriars Road. The thoroughfare was once part of the Great North Road; in the post-war years it was regularly jammed with traffic due to Doncaster's location on major north-south and east-west routes. Congestion was eased with the development of new roads that encircled the town, and the construction of the A1 between Blyth and Red House at Adwick. The western side of French Gate (visible towards the left) was entirely demolished from the early 1960s to make way for the building of the Arndale shopping centre, now known as Frenchgate. Buildings lost in this development included a number of pubs, most notably the Angel & Royal, where Queen Victoria once stayed. Traffic is presently absent from French Gate following pedestrianisation

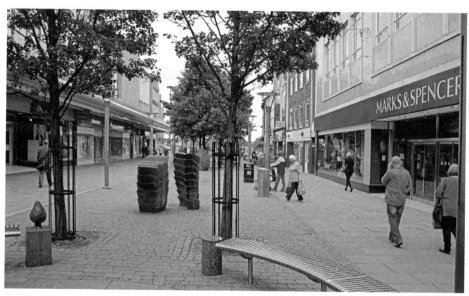

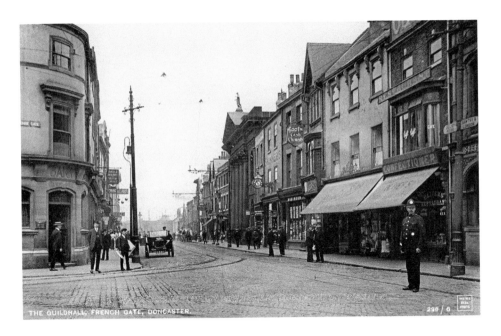

THE GUILDHALL, FRENCH GATE, DONCASTER.

French Gate

Many of Doncaster's notable buildings were demolished during massive redevelopment in the 1960s, but none garnered more public outrage than the loss of the Guild Hall (seen above, to the right). The building was completed in 1848 and was designed with a bold neo classical façade, Corinthian columns and a pediment featuring a figure of Lady Justice; contained within the building were: law courts, the police headquarters, a number cells and a council chamber. By the 1960s the premises had outlived their usefulness and their varied activities were transferred to other areas of the town. The Guild Hall was demolished in around 1968 and the site taken by Marks & Spencer to connect internally with their Baxter Gate store.

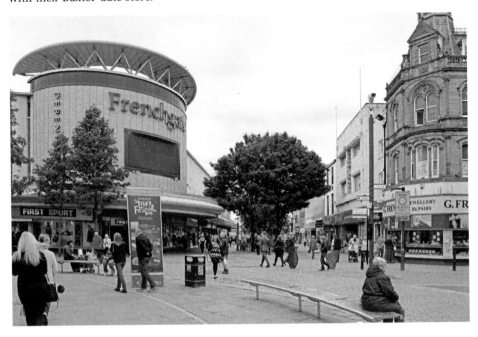

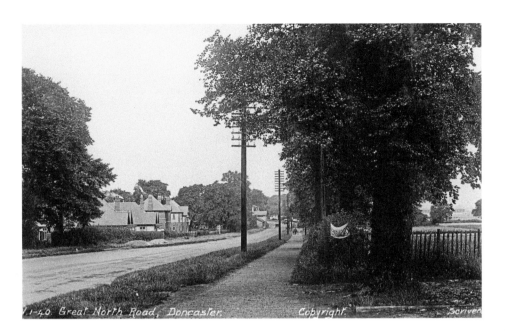

Great North Road

Formerly the main highway stretching between London and Scotland, the Great North Road developed into a coaching route frequented by mail coaches travelling to and from the two points. In later years, the road was largely superseded by the A1. Looking north, the section of the Great North Road (seen above around 1925) is presently titled Bawtry Road. To the extreme right is a glimpse of the Doncaster Racecourse and stands. Interestingly, Tom Bradley in his *Old Coaching Days in Yorkshire* (1889) described the stretch of road between Bawtry and Doncaster as one of the finest in England. Throughout the twentieth century, motor vehicle garages were built in great numbers along the Great North Road; the Racecourse Garage would soon be built near the centre of the top picture in the area dominated by the large trees.

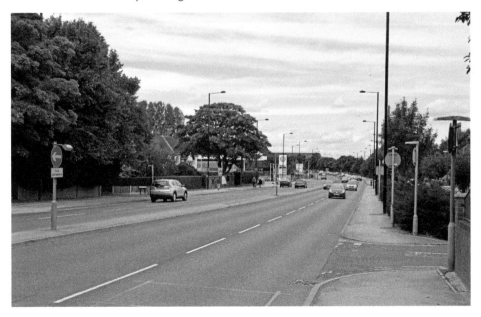

33

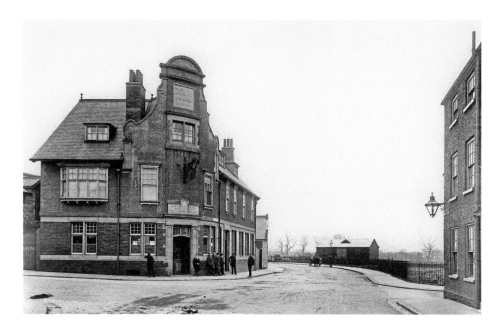

Greyfriars Road

Greyfriars Road, which extends from French Gate to High Fishergate, came into being around 1901 mainly to provide an alternative route from the Great Northern Railway cattle docks to the cattle market. Undertaken by Doncaster Corporation, part of the work involved setting back Ye Old Crown Hotel, traceable from at least 1795, to a new street line at the junction with Church Street. The new premises, seen above on the left, were designed by local architects Athron & Beck. They were renamed Grey Friars Inn during 1996 before closure in 1998. This is one of an increasing number of old Doncaster pubs that have closed in recent times. But, unlike many that have been demolished, the building has found an alternative commercial use. Greyfriars Road has since been shortened; traffic can no longer connect to High Fishergate or the new Markets roundabout.

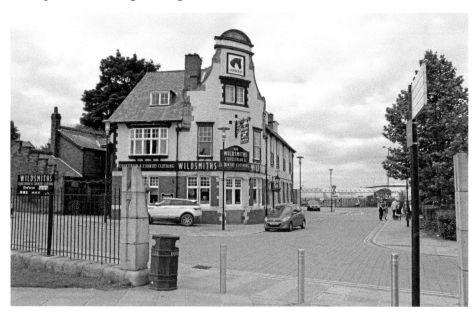

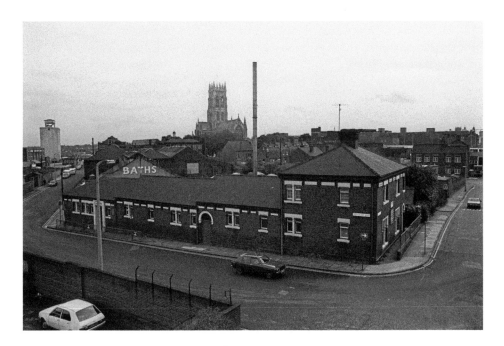

Greyfriars Road

Greyfriars Road stretches over land that was once associated with a friary and run by a group of Franciscan of Grey Friars – hence the name for the road. It was established in the thirteenth century, but was ultimately destroyed with the dissolution of the monasteries during 1536–40. The public baths, as seen above, pre-date the formation of the road (1901) and were situated on a short length which extended from French Gate, later to become part of Greyfriars Road. They were opened in 1892 but cleared along with other buildings, including the tram/trolleybus shed, a school and several streets during the 1980s, when a Tesco supermarket was built on the area.

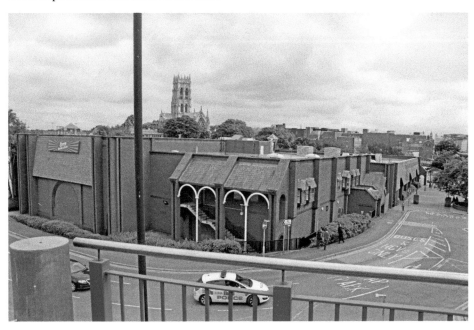

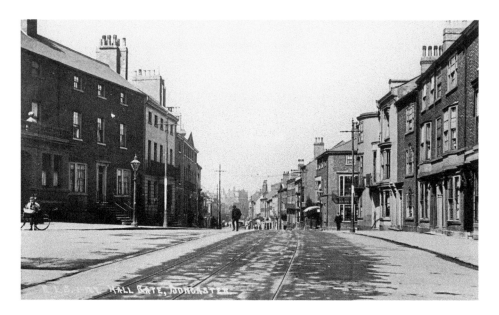

Hallgate

One of the earliest references to Hallgate is from 1507, it mentions a 'messuage outside Halgate Bar', meaning it was outside the bar-dyke or town ditch. Although once housing the poor, Hallgate was transformed during the late eighteenth century when three-storey Georgian houses were built along the thoroughfare. The brow of the street was lowered by the Doncaster Corporation in 1793, which resulted in the cross of Ote de Tilli being removed to Hall Cross Hill. Over the years, public opinion is virtually unanimous in stating there have been many dreadful alterations along Hallgate. Some have even been undertaken since 1974 when the area was designated a building conservation area. The view in these images is looking north; the entrance to Prince Street is on the right, where the corner premises were designed (*c.* 1798), by the architect William Lindley. Electric trams travelled along Hallgate on their way to the Racecourse; tracks are visible in the top picture.

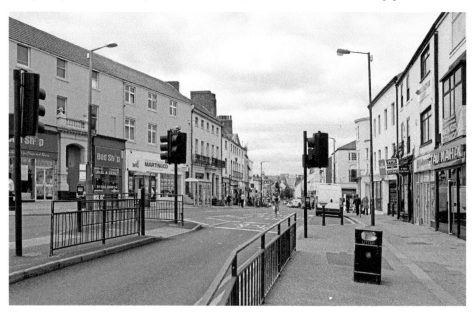

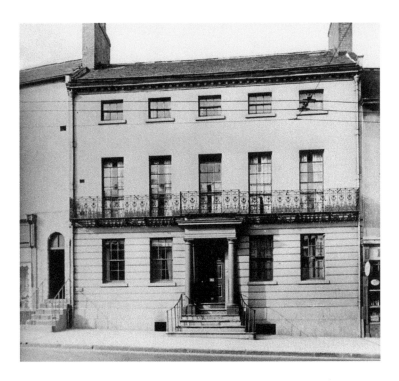

Hallgate

The top picture dates from the early 1950s. It shows the building when it belonged to Dr Reginald Wilson, before it was sold in September 1954 to Francis Sinclair Ltd for conversion into business premises. This is a good example of a private dwelling in Hall Gate being turned over to commercial use; the harmony between ground and upper floors were lost forever. Dating from the late eighteenth century, the premises were formerly the home of Dr A. Christie Wilson who set up practice in 1872. Prior to the sale of the house in 1954, it was used as a surgery by Dr Wilson's son, Dr Reginald Wilson, and remained the home of Miss Eleanor Wilson. Display windows were inserted at ground floor level by Francis Sinclair Ltd, who sold glass, china and fancy goods; he moved from the site around 2000.

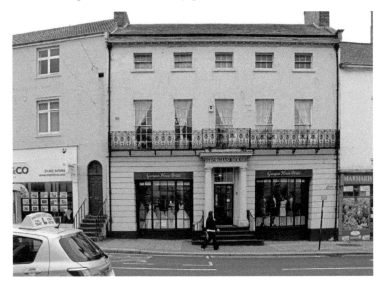

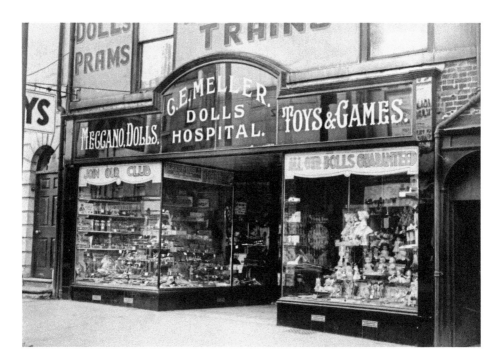

Hallgate

During the late nineteenth century, George Meller and his son Charles Edward had a cabinet-making and undertaking business at the Scot Lane/Market Place corner. By the early 1920s the store carried a large 'Dolls Hospital' sign; there were also adverts in the shop window for Hornby Trains. Due to the Scot Lane widening scheme, carried out later in the decade, Charles Edward moved the business to No. 55 Hallgate. He ran the new Doll's Hospital store, which also sold many different brands of toys and bicycles, with his son Granville and daughter-in-law Leila. They enjoyed immense success particularly throughout the post-war years, until the business was sold in 1959 to Lines Bros of London. The latter company continued trading under the name of Meller's Dolls Hospital for a time, but it was eventually renamed Youngsters. Closure came in September 1979 and that marked the end of a toy-selling era in Doncaster.

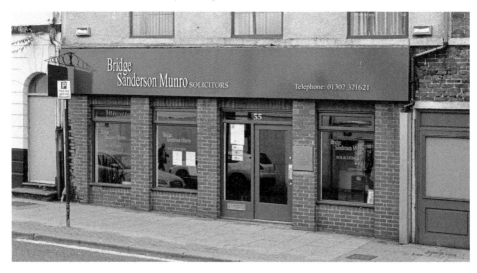

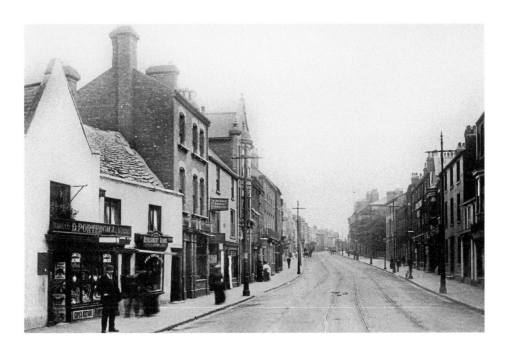

Hallgate

An old property that dated to 1300–1400 stood at the Hallgate/Silver Street corner until around 1912, when it was demolished to make room for the construction of the Prudential building. Further along was the White Bear public house, presently titled Flares & Reflex. The White Bear can be traced to at least 1779 and for a time the Eclipse coach ran to Sheffield from there. The premises were rebuilt in 1885, extended in 1925, and alterations took place in 1959 and 1988. While Flares & Reflex might be praised for playing the best '70s, '80s and early '90s tunes to keep everyone dancing all night, it is unfortunate that the eighteenth-century name 'White Bear' has been lost – not to mention the large bear, once suspended outside the premises.

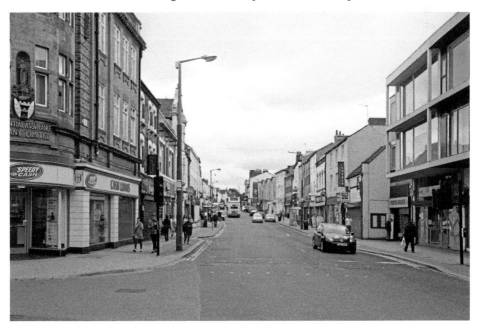

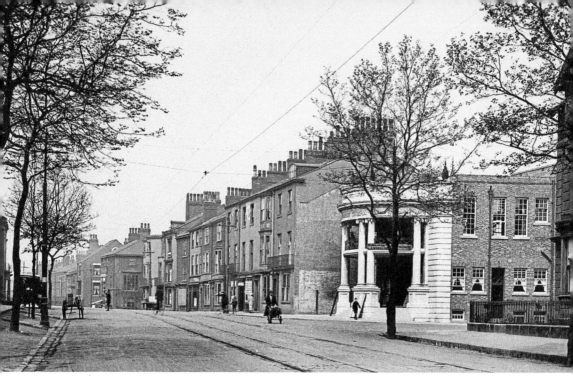

Hallgate/South Parade Junction

The South Parade Cinema (seen to the right of the above image), was completed in December 1920 on the site of a large property, known as South Parade House. Funding came from a dentist named A. E. Reed, with construction costs amounting to around £24,000; the building could accommodate 1,800 patrons, with 700 in the balcony. The name was changed to Majestic in 22 September 1922 when it came under new management. Sound was introduced in September 1929 but closure came in 1933 after being acquired by Provincial Cinematograph Theatres. The Gaumont Cinema (see following page) was subsequently erected on the site.

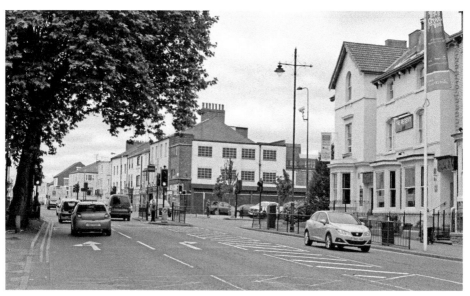

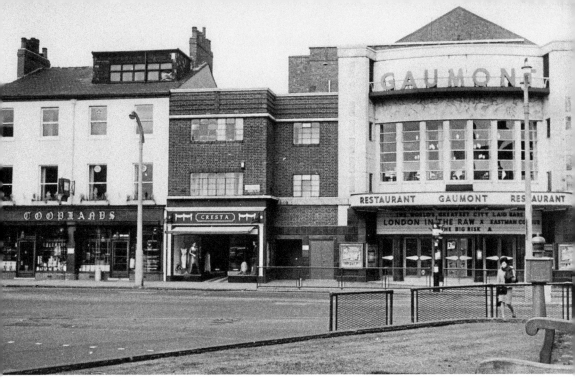

Hallgate

Cooplands' Hallgate bakery business was established by Alice Jenkinson (née Coopland) in 1931. Thereafter, the family-run business enjoyed tremendous success with branches established over a wide radius and employing hundreds of staff. The original Cooplands' Hallgate site was developed as the Hallcross pub during December 1981; it became Dr Browns in May 1997, but was subsequently renamed Hallcross once again. The Gaumont cinema opened on 3 September 1934, it featured a frieze by sculptor Newbury Trent on the outside that depicted the growth of a film in its various stages. The premises became the Odeon in January 1987 and were demolished in spite of a public outcry in 2009.

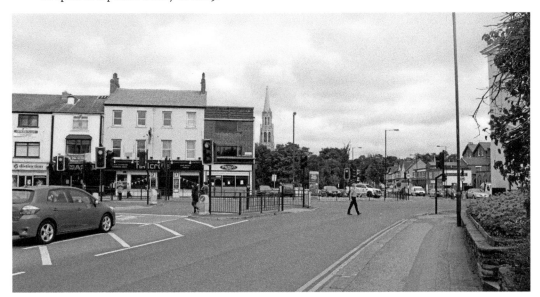

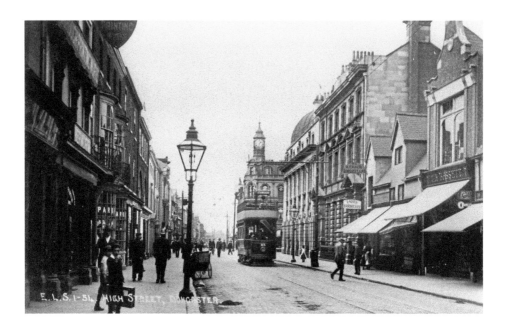

High Street

This pair of photographs shows the High Street, looking north. In the top picture, car No. 25 is starting on its outward journey to the racecourse. It was acquired by the Doncaster Corporation in 1904 and the car received a top deck cover in 1913, placing the date of the picture within a nine year period. Trams gave-way to trolleybuses and, in turn, they were replaced by motorbuses on the racecourse route; all forms of public transport are now absent from the section of High Street between Priory Place and Baxter Gate today. The building on the right at the Baxter Gate junction was formerly the York City & County Bank, built in 1898. Next door was the Yorkshire Banking Co., whose premises were built in 1885. On the opposite side, and now gone, was the confectionery business of Samuel Parkinson; he had a world wide reputation for his butterscotch.

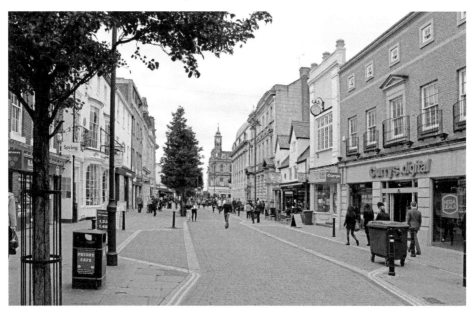

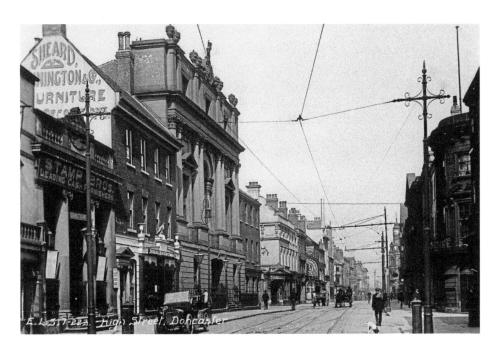

High Street

Many of the buildings on this section of the High Street, between Hallgate and Priory Place, have undergone considerable external alterations since the above picture was taken, including: Sheard, Binnington's premises, the Subscription Rooms and even the bank at the Priory Place/High Street Corner. But the jewel in High Street's crown, the Mansion House, now one of only three in the country, has remained unaffected on the outside for over two centuries. Completed in 1748 to the designs of James Paine, the building was extended by William Lindley between 1801–06. The use of the Mansion House has been varied. In the early days it was used as a courthouse for petty sessions and a court room, whereas in more recent times a number of the rooms have been used by Doncaster Council for holding committee meetings.

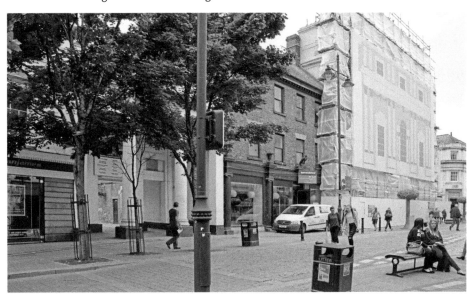

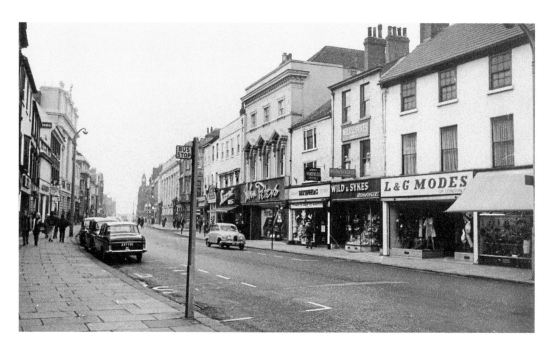

High Street

The main changes in the intervening years include the restriction of vehicular traffic travelling in both directions along the street, the adoption of double yellow parking lines; the introduction of seating and waste bins, and the planting of trees. The ground floor commercial premises continue to have no relation to the upper floors, some of which look extremely dilapidated; for example, the former Palladian-style Lyceum Restaurant just off-centre to the left of the image. Long-time traders on the street have also gone, such as Wild & Sykes' ironmongery business at No. 23. On the positive side, and quite welcome, is the use of space in front of the Zest Cafe bar, giving it a continental feel.

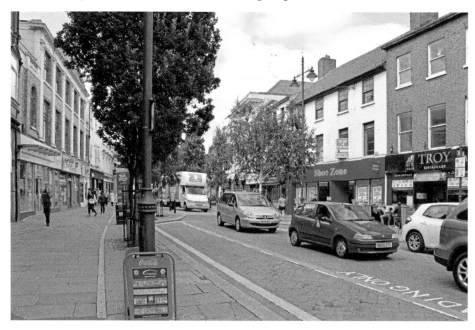

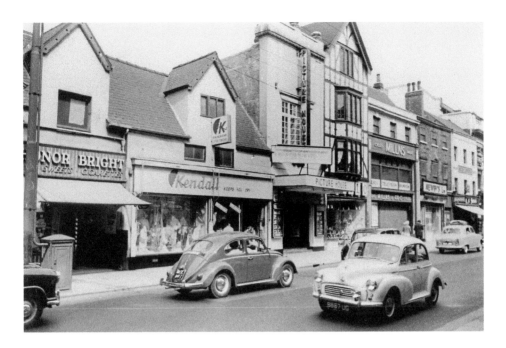

High Street

A group of timber-framed properties that likely date to the sixteenth century. At the time that the picture was taken they were tenanted by Honor Bright (sweets and cigarettes) and Kendall (rainwear and sportswear). Next-door is the Picture House, which existed between 1914–1967; afterwards it operated for a period as a bingo hall. *A Week-End with Lulu* (1961) was showing at the cinema at the time of the photograph. The Picture House was once one of quite a number of town-centre cinemas, but now there are none. At No. 9 High Street, Milns' cycles, motorcycles, wireless and gramophone business, moved to High Street during March 1933. They had traded in St Sepulchre Gate for the previous twenty years and moved from High Street sometime during the 1960s.

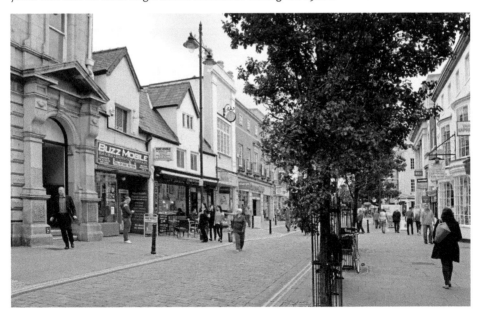

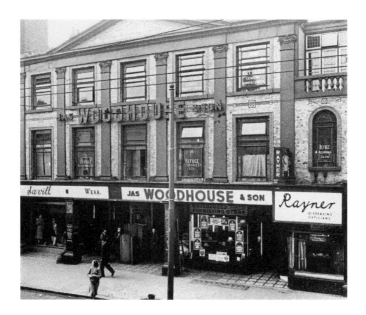

High Street

Local architect, William Lindley, designed the three-storey premises here; they accommodated the New Bank between 1812 and 1847. The unsightly blue and gold mosaic tiles were added during the early 1920s when the premises became known as Westminster Buildings. The *Doncaster Gazette* of 10 August 1923 headed an article with a picture of the building and asked pointedly, 'Is the central area of the town losing a good deal of its old world character in the process of business expansion? Houses and shops characteristic of the Georgian period are being altered with little regard to the architectural style to which they have hitherto conformed'. It was also added that nowhere is this better illustrated than in the building above, 'which has just been modernised'. Unfortunately, the gaudy tiles are still in evidence today and the building is still used for a variety of commercial purposes; yet, there have been no recent sightings of the ghost which reputedly once haunted the site.

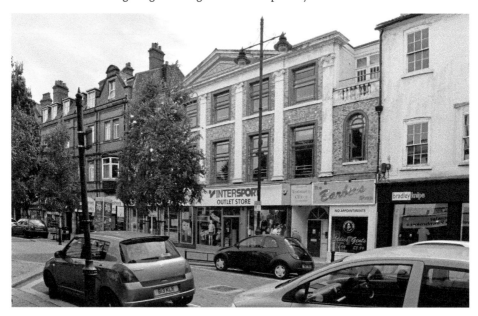

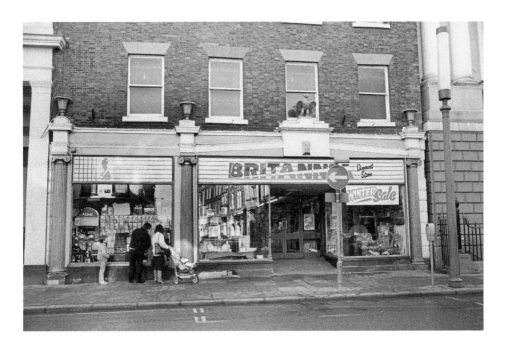

High Street

The history and changes within these premises can be traced back nearly 200 years. Drapers, furnishers and wine merchants, J. Mawe & Son, were noted as running their business from a property adjoining the Mansion House from at least 1819. Later, from 1885, a cabinet-making and furnishing business traded from the building and was run by Sheard, Binnington & Co. The firm flourished and was popular with the Doncaster public. This lasted until 1953 when the company was taken over by Harrison Gibson Ltd, who in turn gave way to Eyres Ltd, followed by Braithwates, and Britannia Ltd (seen in the top picture). After many more changes, the building exists today as a Chinese buffet.

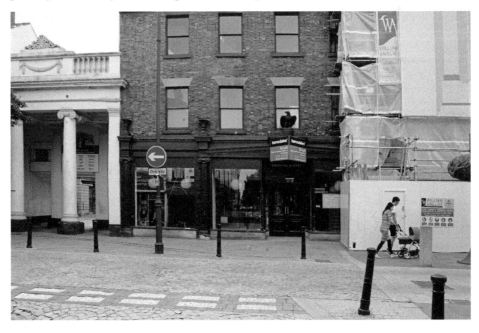

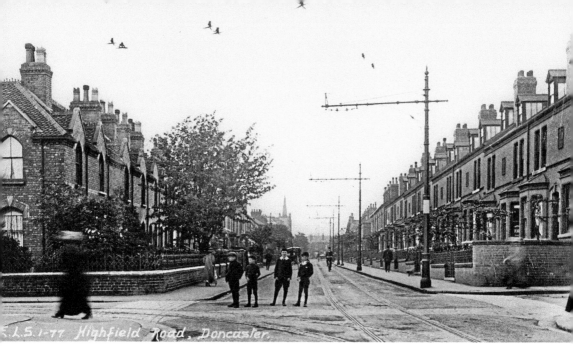

Highfield Road

In this image Highfield Road can be seen facing east from the Nether Hall Road/Broxholme Lane junction. The junction was formerly the point where the Becket and Avenue Road tram routes split and went their separate ways. The top picture was taken when Highfield Road was a quiet residential area; the properties boasted walled gardens interspersed with trees. Houses along the thoroughfare can be dated to the late nineteenth and early twentieth centuries. Similar to Copley Road, Highfield Road is only just recovering from a bad reputation, which was gained via unsavoury nocturnal activities over the previous thirty-or-so years. This recovery has been brought about through the untiring efforts of residents, the police and other agencies.

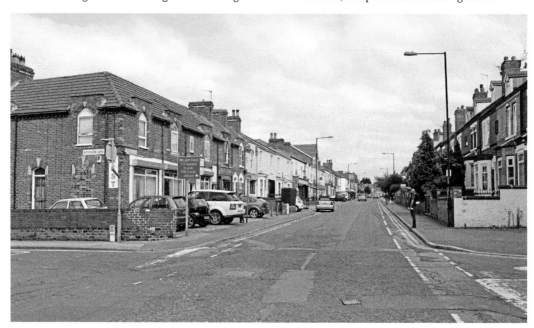

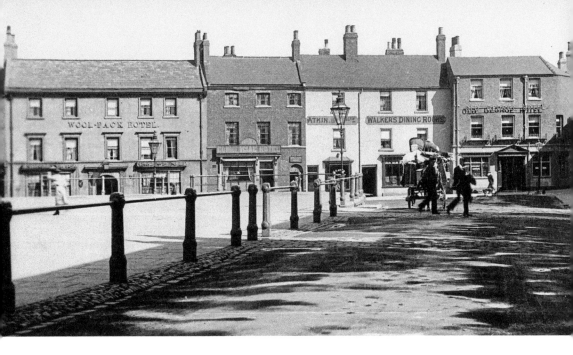

Market Place

The view in these images is looking towards the south-west corner of the Market Place. In the top picture there are three pubs: the Woolpack, Waverley Commercial Hotel and the Old George. To give some idea of their age, the Woolpack may be traced to at least 1707 and the Old George to around 1800. The Waverley only existed here between 1909 and 1920. Nonetheless, this is one area of the town where two buildings are still carrying out the same function that they have done for the past 200 years, through trading practices and the landlord's role are much altered today. The Old George's name has been changed, and that is regrettable, but who knows, alterations of this type have a habit of returning back to their original state. It will all depend on how pub trends develop in the future.

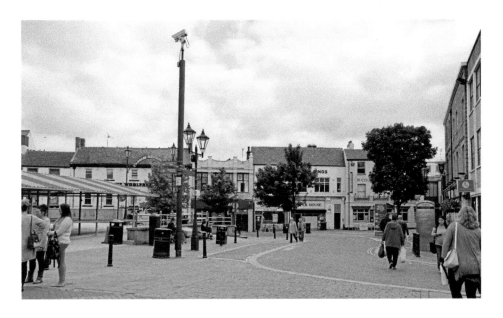

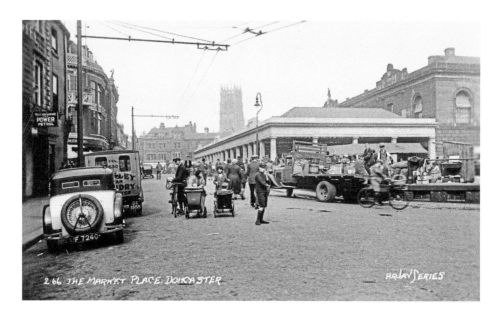

2.66 THE MARKET PLACE. DONCASTER. ARJAY SERIES

Market Place

The present-day Market Place is probably in the same area as one that may be traced back to Roman times. In the medieval period the market developed around the church of St Mary Magdalen, which once occupied a prominent position in the area and was considered to be the original parish church. If it existed today, the church would cut across to the right at an angle; instead the New Market Hall partially occupies the site, which was completed in 1849. Straight ahead is the extension to the New Market Hall, erected in 1930. Apart from the introduction of a pedestrianised area in the stretch now known as Goose Hill, the main change affecting the entire Market Place is probably not easily visible. This is because lack of free car parking around the area and competition from large supermarkets has brought great pressure on traders struggling to earn a living.

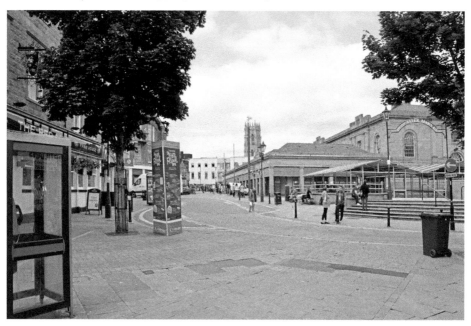

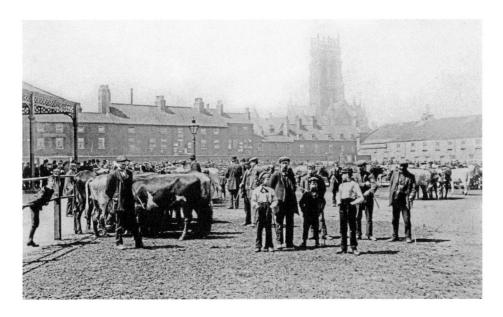

Market Place

The area seen here once formed part of the Parsonage Yard, where cattle were sold from 1781. The area was also used for public meetings and festivities. St George's church is in the distance, along with a row of houses in High Fisher Gate (formerly Soa Stang Lane). The cattle auctions were extended in 1869 causing the demolition of a number of buildings, including several tithe barns and the White Horse Inn. To complete the work the Corporation acquired the Parsonage Yard (up until that time they had leased) from the Ecclesiastic Commissioners in 1864. Further extensions were made towards Friendly Street in 1908 and this included the construction of an octagonal auction ring. Eric Braim in the *Doncaster Civic Trust Newsletter* of November 1986 commented, 'The cattle market was removed to Dockin Hill about 1960. The Parsonage Yard is now a treeless car park and a jumble of untidy stalls.'

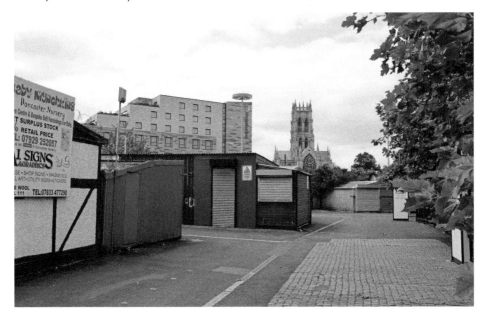

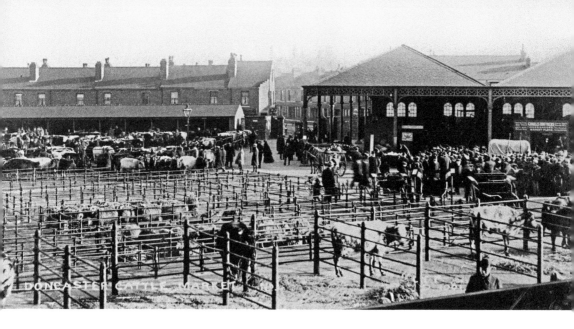

Market Place

In this photograph, looking towards Market Road, Copley Road and the entrance to the Cattle Market, the Wool Market can be seen to the right. In 1862 there were efforts to build a covered wool market in the southern area of Parsonage Yard, and for the demolition of properties in Shaw's Yard. The Corporation Steward, J. Butterfield, prepared the plans and eight years later the building was extended. Built from brick and cast- and wrought-iron, slate and glass, over the years the Wool Market has been transformed into a general market; it is the most diverse of the town's market halls, where a whole variety of items may be found. Also, the structure achieved Grade-II listing status in September 1988 for its historical interest.

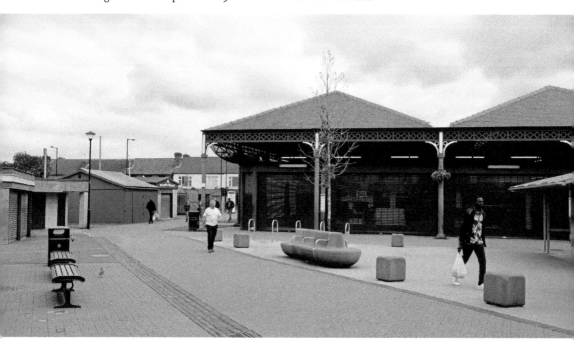

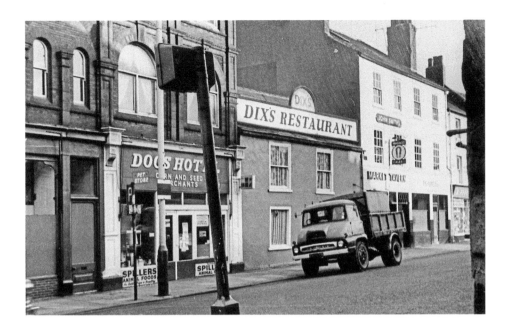

Market Place

Following the Sunny Bar widening scheme, the tall building to the left was constructed around 1902 on the southern side of the Market Place. One of the casualties of the development was the Black Swan public house; the full licence of which was transferred to the Plant Hotel at Hexthorpe, which at the time was only licensed to sell beer. Dix's Dining Rooms was empty for a number of years before being demolished in 2012 after a roof collapse. A victim of closure and redevelopment in 1978 was the Market Inn (or Tavern), which had existed on that site from at least 1870. Since the time of the above picture, the road is now one-way with parking thoughtfully provided for market shoppers; R. Anson & Son (as seen in the above picture) is still trading today.

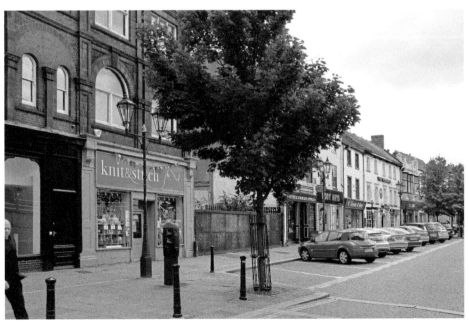

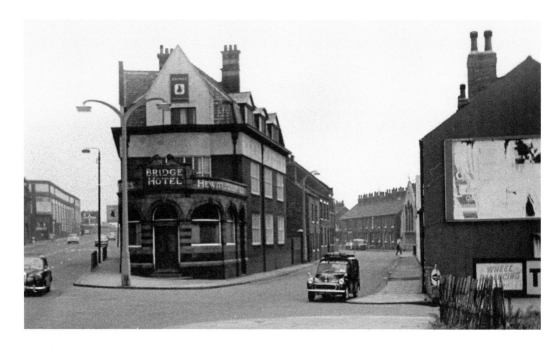

Marshgate

Not much remains of the above scene which depicts Marshgate during the 1960s. However, this appearance had only existed from around 1910 when the North Bridge, seen to the left, was constructed and resulted in much remodelling in the area. A newcomer to the scene was the Bridge Hotel; built by Hewitt's Brewery of Grimsby, on land not required for the bridge works. The Hotel took the licence of the old Labour in Vain pub. All the properties, along with St Andrews church (visible to the right, in the distance), were cleared around 1970. Following Marshgate's redevelopment during the 1970s, light industry took root there, but the area is presently more widely-known for the prison (HMP Doncaster), out of view to the right. This was opened on the old power station site in 1994. It was Doncaster's first prison to open since the one in the town centre was demolished during the mid-nineteenth century.

Nether Hall

At one time Nether Hall was in the centre of a thirty-acre woodland park. There are conflicting reports in newspapers over the hall's origins, but the British Listed Buildings website quotes a building date of early-to-mid-eighteenth century. However, there is no doubt that Nether Hall once belonged to the Copley family, but it thereafter passed to various people until Doncaster Rural District Council took control in 1921. The premises were altered during 1935 and later, in the 1980s, occupied by the DMBC's Finance Department. The council used the property until moving to purpose-built offices in Waterdale. The Grade-II listed Nether Hall was then sold by public auction during October 2014 for £410, 000.

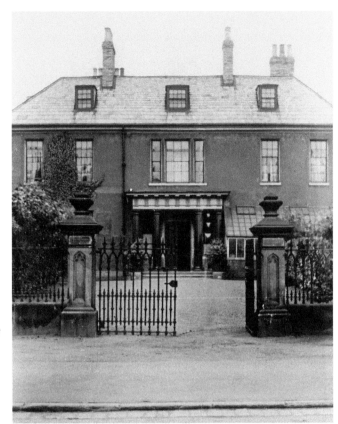

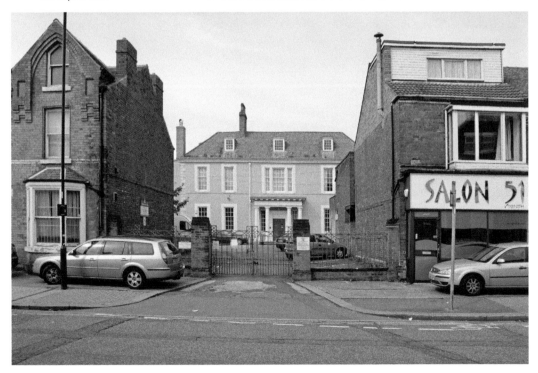

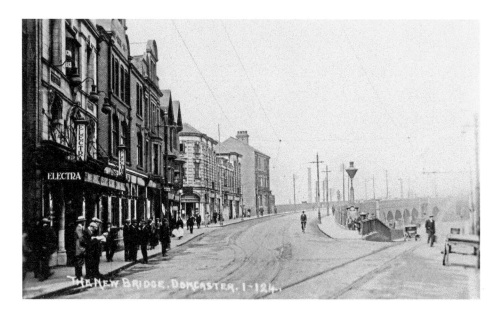

North Bridge

All the buildings to the left in the above picture date from the time of the North Bridge construction, which was completed in 1910. The buildings include: the Electra Picture Palace (later The Regal), the Bay Horse public house, the business premises of G. Simpson at the corner of the newly-built Trafford Street and the Brown Cow public house. North Bridge was designed by an eminent engineer, Edward Parry, and the building work was carried out by the local firm H. Arnold and Son. The properties up to Trafford Street were demolished in the early 1960s to make way for the Arndale (now the Frenchgate Centre) and the Brown Cow was lost in 1964. The east-bound by-pass scythed through the area then, truncating French Gate on the right. Recent developments include the massive extension to the Frenchgate Centre and creation of a transport interchange, both completed in June 2006.

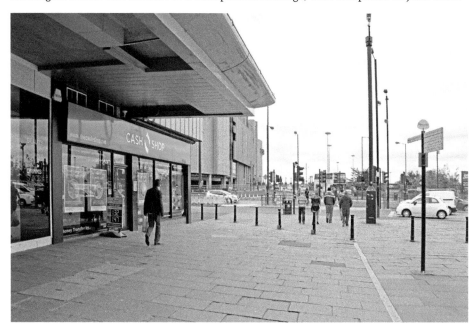

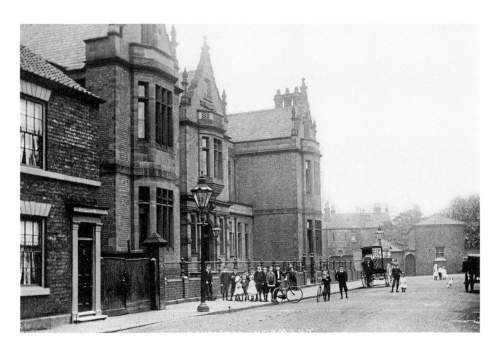

Princegate/Whitaker Street

The street depicted, looking towards Wood Street, was formerly titled Whitaker Street (laid out around the 1820s) but a name change occured – to Princegate – during the mid-1960s when the area was intended to form part of the Golden Acres (now Waterdale) shopping centre. The large building depicted once housed the Public Infirmary and Dispensary and was completed in 1868 to the designs of Brundell and Arnold. This was superseded in August 1930 when a new Infirmary was built at the Thorne Road/Armthorpe Road junction. In time, the old building eventually became the offices of the town's Education Department, but was demolished under controversial circumstances in 1993.

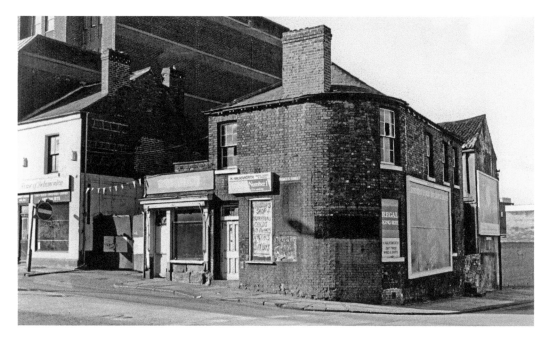

Prince's Street/East Laith Gate Corner

The top photograph was taken during January 1990, five years after Phillip Steadman (co-director to one of the town's oldest family-run firms) died and the premises had been vacant for a time. The business was started by Charles G. Steadman in 1873 and it proudly adopted the 'By Royal Appointment' badge after ferrying the future King Edward VII to a Doncaster race meeting. The firm was expanded by Graham Steadman's son, Frank; after Phillip and his brother Dennis took over, a fleet of cars was introduced. Later in the 1990s, the old premises were demolished and the site redeveloped to accommodate Lazarus House. Sadly, this meant the loss of one the town's unique rounded street corners.

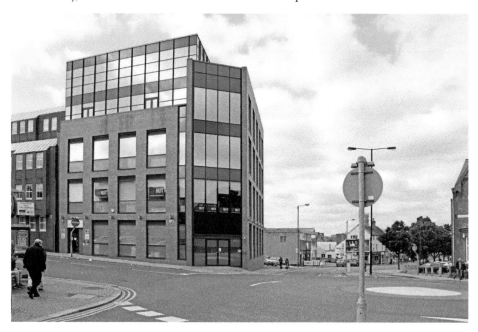

Prince's Street

Prince's Street, extending between Hall Gate and Thorne Road, was laid out in 1795. The photograph to the right, looking to Thorne Road, the main building on the street is the Roman Catholic church of St Peter-in Chains. It was erected in 1867 on the site of a previous church also dedicated to St Peter. The new church was designed by Sheffield architects Messrs Hadfield & Son; red bricks with stone dressings were used in the building's construction. It also featured a large rose-window and two lancet-windows at the front over the main entrance, in addition to an impressive bell turret. The entire building was demolished during the early 1970s and a new church completed in Chequer Road in 1973 took the same name. Many of the buildings in the top picture have gone or are badly disfigured; apart from properties at the Hall Gate entrance, the street currently presents a mix of architectural styles, with little coherence or adherence to street scale.

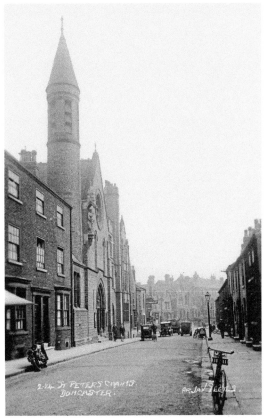

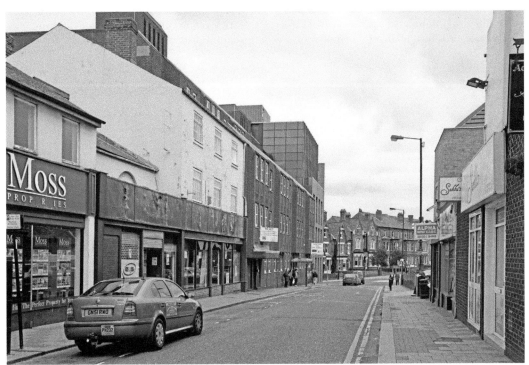

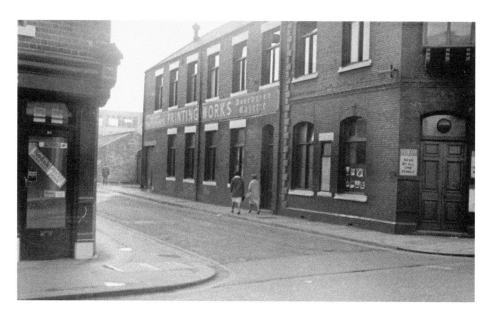

Printing Office Street/Pell's Close Corner

After several moves around the town, a printing works was established in the aptly named Printing Office Street in 1834. William Sheardown established the newspaper in January 1794, it was originally titled the *Yorkshire, Nottinghamshire and Lincolnshire Gazette and Universal Advertiser*. Four years later the newspaper absorbed *The Yorkshire Journal and General Weekly*, first printed in August 1786. Above, a section of the *Gazette's* printing works are seen at the Printing Office Street/Pell's Close corner on 23 October 1966. The works were demolished in early 1980 after standing empty for around thirteen years and the site was re-developed shortly afterwards. The newspaper was printed elsewhere and survived until 1981. New commercial premises on the site were built of brick, for many people this was a welcome return after an uninspiring era during the post-war years of concrete and glass. The building also blended reasonably well with much of the remainder of the street.

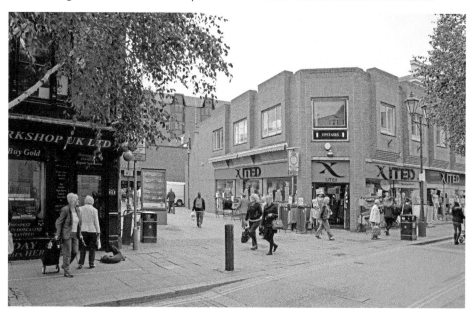

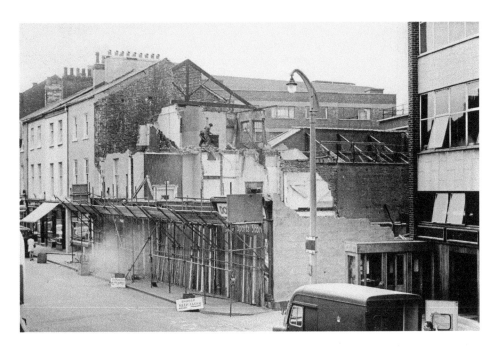

Priory Place

A new street was laid out between High Street and Printing Office Street around 1830 and local architect William Hurst designed a number of the well-proportioned three-storey houses on the south-eastern side. Those opposite were erected later in the century; in fact, an 1852 OS map shows parts of that section of the street still vacant. A post office opened on the north-western side in 1885 and in subsequent years many of the properties on both sides were converted for commercial use. Priory Place survived a plan to run a main road along its route in around 1965, but unfortunately did not dodge another such scheme at the end of the decade. This resulted in the demolition of several three-storey properties, illustrated above on 26 September 1970.

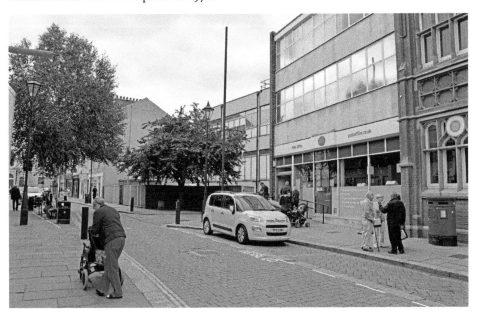

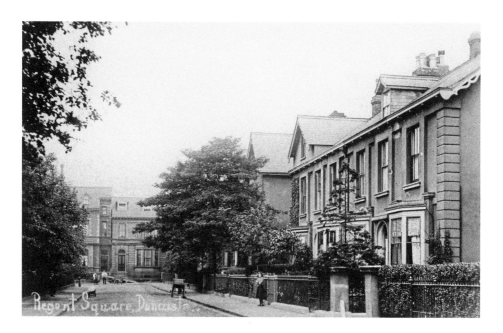

Regent Square

Regent Square was laid out in building plots during the early 1850s and eventually comprised of stuccoed terraced town houses. When compared to some other areas of the town, the Regent Square houses seen here remain relatively unscathed from twentieth century additions and developments. The area to the left was obtained by the Doncaster Corporation in 1858 following a land exchange and subsequently laid out as a formal 'garden square'. Perhaps surprisingly, it was not exclusively for the use of residents and was only open to the public on rare occasions for the remainder of the nineteenth century. It was intended as an ornament to the town. When it was transferred from the Estates Committee to the Parks Committee in January 1935, the area was opened to the public. It is also worth mentioning that the inclusion of the 'modern' Victorian lamps is a nice touch.

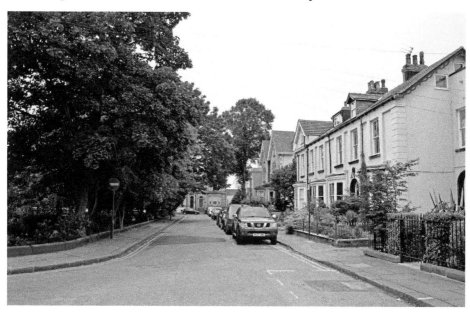

St George Gate

St George Gate once provided a direct route from the town centre to St George's church, rebuilt to the designs of Sir George Gilbert Scot in 1858. The road was shortened following the construction of Church Way, leaving the church marooned from the town centre. Before construction on the road began, arguments were put forward for a dive-under, past the church; these were rejected for being impractical. Two pubs – the White Lion and Waverley Hotel – were also lost to the new road. Other business premises to be found among the once familiar Georgian buildings were those belonging to photographers Garrison & Deakin.

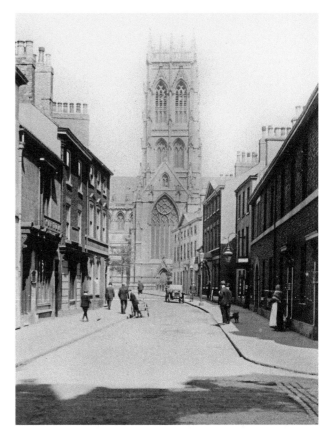

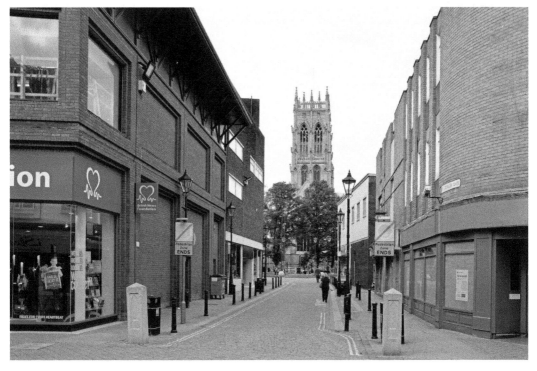

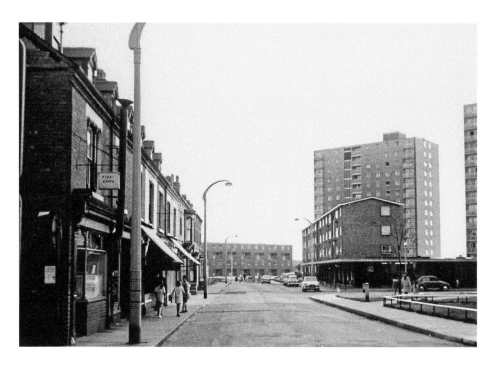

St James Street

Some of the original houses on St James' Street date from the early nineteenth century; the 1891 census reveals 142 households on the street. In time, the thoroughfare became one of the town's main routes for traffic that travelled to-and-from the west, which existed until the post-war years when Doncaster's Development Plan was put into operation. The town centre was allocated specific uses and much of the property in St James' Street (including the adjacent areas) was cleared under a number of CPOs, then redeveloped. There was no provision in the Development Plan for St James' Street to remain an east-west route through Doncaster. The group of high-rise flats in the St James Street area have now been in existence for around fifty years and have outlived similar, but more controversial, schemes around the country – particularly Hyde Park at Sheffield.

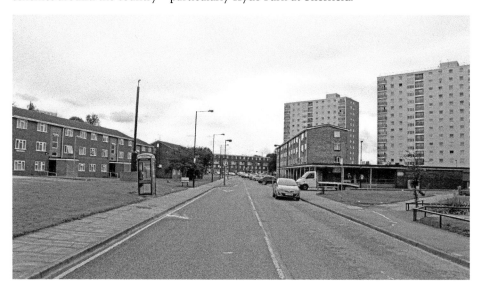

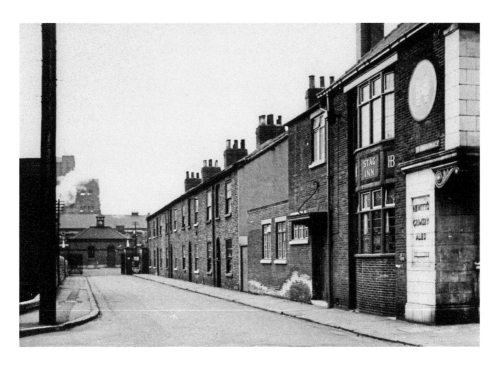

St Leger Place

The top view, taken around 1960, looks north along St Leger Place towards the gas works. The complex was established by the Gas Light Co. in 1827; Doncaster's streets were first lit by gas in the September of the same year. The works were built by the side of the canal, enabling barges to deliver the coal that was needed to produce gas. The company was bought out completely by the Doncaster Corporation in 1858. Production of gas continued on the site until 1969. Thereafter most of the works were demolished and the inner relief-road scythed through the former site. The Stag public house (seen to the right of the above image) had its foundations in *c.* 1838, but was rebuilt in 1935. As seen below, St Leger Place is now considerably smaller.

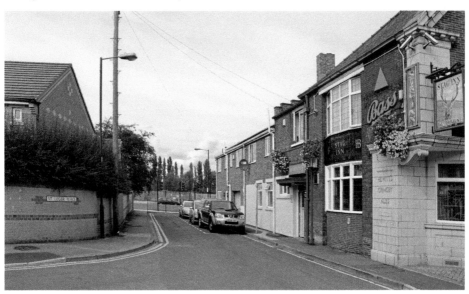

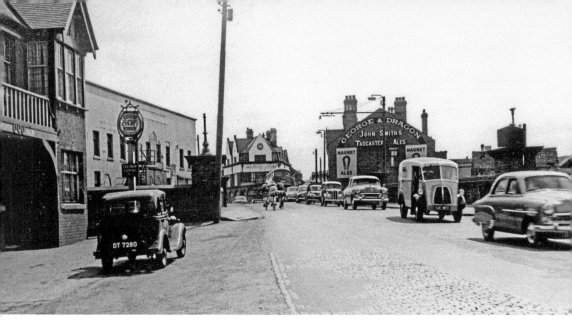

St Mary's Bridge

The above photograph was taken before work commenced on the Mill Bridge and old lock improvement scheme on 1 October 1956. The earliest record of a bridge on the site was during the reign of Henry VIII by the historian Leland, although it is almost certain that a bridge has existed here since the time of the Normans. The design of the new bridge substructure, road works, retaining walls and flood culvert was carried out by Fred Bamforth. The main contractors were Messrs Holland & Hannen & Cubbitts (Great Britain) Ltd. It was opened on 27 November 1959 and was intended to cater for both the character and weight of modern traffic, which had reached a level of 25,000 vehicles per day. The two pubs in the distance (the Bridge Hotel and the George and Dragon) no longer survive. The latter's licence was transferred to new premises, the Toby Jug, on the opposite side of the road. The Three Horse Shoes to the left may be traced to at least 1783 and was rebuilt in 1913.

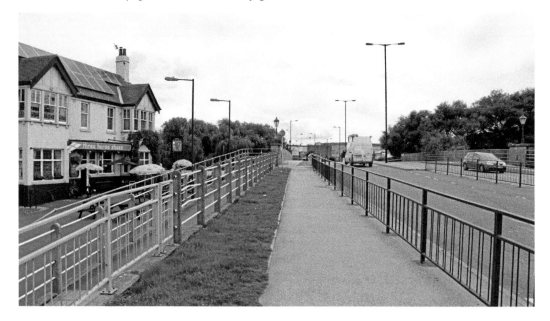

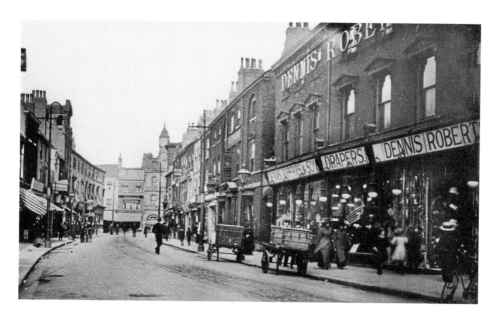

St Sepulchre Gate

Dennis Roberts was born in 1811 at Ragnall (near Retford), the son of a farmer and grazier. Around 1873 he moved, along with his son Walter, from a store in the Market Place to No. 21 St Sepulchre Gate and began trading as Dennis Roberts & Son. The firm was involved with millinery, drapery, ladies and children's outfitting; the business grew and eventually took over adjoining shops. Dennis Roberts died in 1896 and Walter passed-away in 1923. Four years after this, the company ceased trading in St Sepulchre Gate following the Doncaster Corporation acquisition of the premises for street-widening. Montague Burton subsequently built a store on the set back street-line. One of Roberts' directors opened new premises in Scot Lane, although this was short-lived.

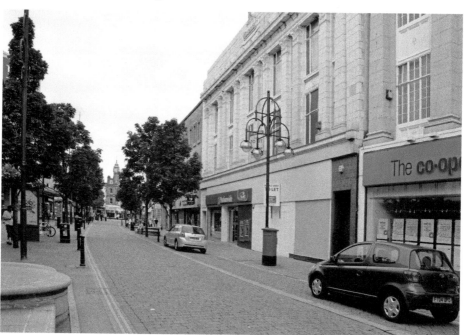

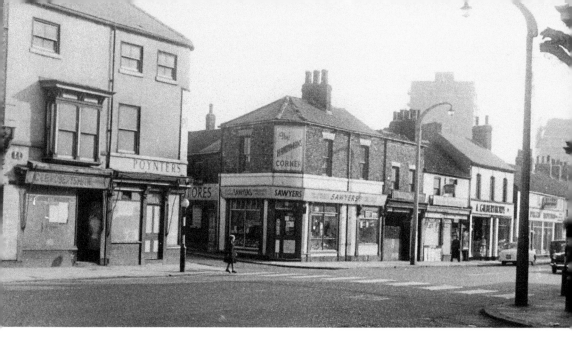

St Sepulchre Gate

The south side of St Sepulchre Gate is depicted above (*circa* 1960). This was prior to the business premises of S. Poynter, the butcher (at the corner of St Thomas Street), and C & E Robertshaw being demolished to facilitate redevelopment in the area. Sawyers Ltd – the handyman's corner – at No. 115 had traded on this site from 1946; they built larger premises in the immediate vicinity around 1964. Further along were other well-known traders, from the days when this section of the St Sepulchre Gate was alive and bustling with activity. The inner relief road, scything through the thoroughfare, has made it difficult for businesses to survive there and caused the properties to become neglected. Nonetheless, an extremely useful addition is the NHS Health Centre, constructed on the site of the enlarged Sawyers building in around 2011.

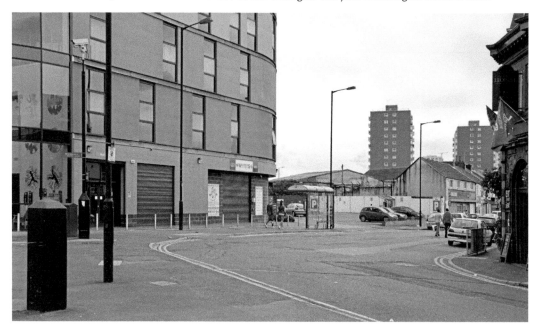

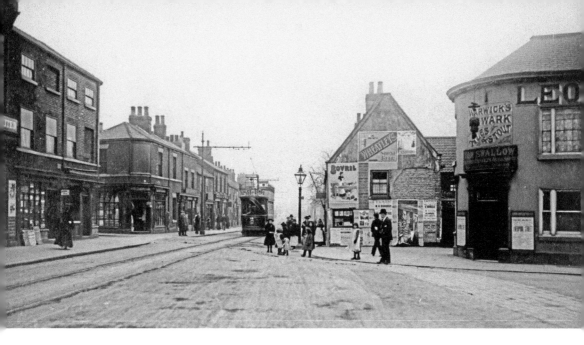

St Sepulchre Gate

All the properties visible on the right of the above image were demolished around 1909 to make way for street widening. This included the demolition of the Leopard public house, which dated from at least 1821. Newark brewers, Warwicks & Richardson, rebuilt the pub to the designs of architects Athron & Beck on a set back street-line. Electric trams that ran on the Hexthorpe and Balby routes (later Warmsworth too), worked along this section of the St Sepulchre Gate route from 1902. When replaced by trolleybuses, in 1929 and 1931 respectively, both services started from a town centre terminus in West Laith Gate and joined the stretch of St Sepulchre Gate depicted here via West Street. It is refreshing to see a town-centre pub like the Leopard still thriving today and providing a venue for live bands to play.

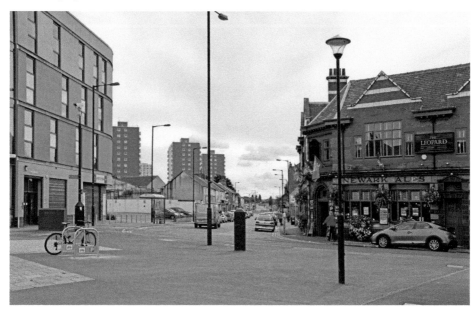

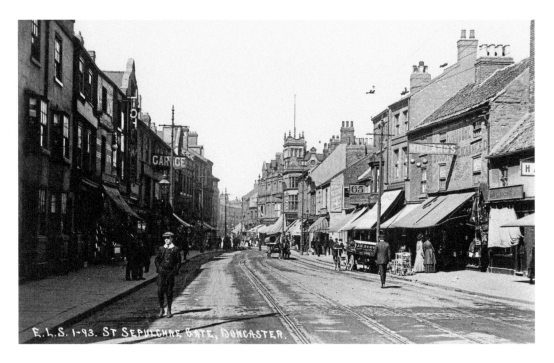

St Sepulchre Gate

St Sepulchre Gate is shown above when it was a hive of activity, stretching from Clock Corner to Balby Bridge (though its full length is not visible here). Currently, the inner relief road dissects the thoroughfare and has added east or west to the name. Modern maps show St Sepulchre Gate ending just beyond St James' Bridge. Only the street's eastern section from Clock Corner to the old Co-op building can claim to be busy today; it presents one of the Frenchgate Centre's main façades. To the left of the above image are two noticeable public houses that are now gone: the Good Woman and Crystal Palace.

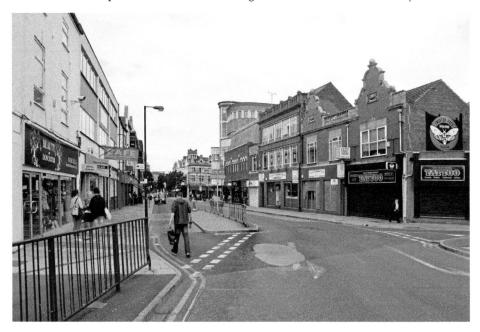

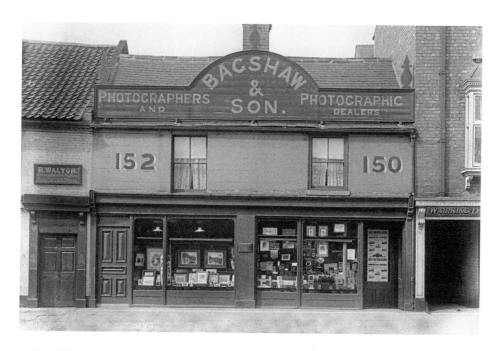

St Sepulchre Gate

John Thomas Bagshaw established Bagshaw & Son in 1897. He involved himself solely with administration while his son, Luke, carried out the photographic work. The business was initially run from Union Street, then St James' Bridge; the move to Nos 150 and 152 St Sepulchre Gate occurred in 1898. The business flourished between 1900 and 1935; Bagshaw & Son became the town's principal photographers and suppliers of photographic equipment. Luke Bagshaw died in 1944 and the business was run by his widow until 1954, and afterwards by Alice Harrison. Between 1965 and 1978, she moved the business to the opposite side of the street. Bagshaw's original St Sepulchre Gate premises have been occupied by a number of business during the intervening years and now appear rather forlorn.

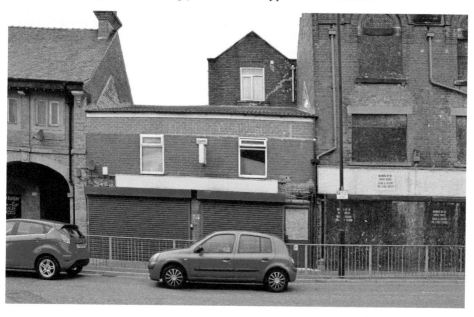

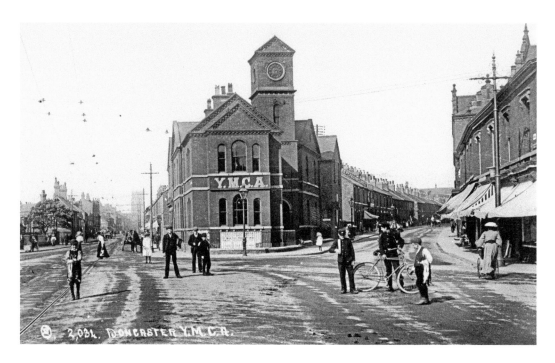

St Sepulchre Gate

The area shown above (looking east towards St George's church) has been completely altered with road improvements and the clearance of the tired mid- to late-nineteenth century housing and commercial premises. Originally constructed as a hospital in 1853 by George Dunn, the central building here eventually became the YMCA headquarters before demolition in around 1963. Around the same time all of the buildings to the right were cleared, including the St John Street Co-op (the tall gabled building just visible) that opened in 1893. The only surviving property is the Corporation Brewery Tap public house (not recognisable above, but can be seen below); it originally dated from around 1855, but was rebuilt after a fire in 1934.

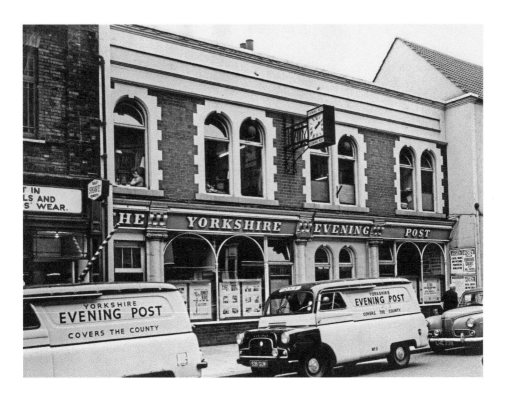

Scot Lane

At one time, the *Yorkshire Evening Post* printed a separate edition for South Yorkshire and was produced in Doncaster. The office was located in Scot Lane (as seen above); the paper was the forerunner of the *Doncaster Evening Post*, which came into being in 1966 and was produced on North Bridge until 1983. Thereafter, the *Doncaster Star* was launched. Sadly, the old *Yorkshire Evening Post* building was demolished in February 1971 and replaced by a new uninspiring structure.

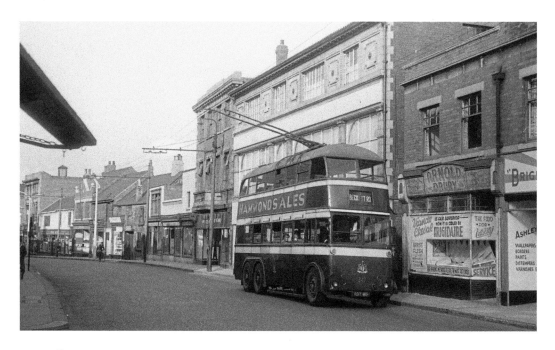

Silver Street

The major changes to occur here may not be immediately obvious; the mode of public transport has switched from trolleybuses to motorbuses, but Silver Street is still part of the town's transport system. Old firms have disappeared; their former premises were converted to bars, or look terribly dilapidated awaiting new tenants. A sign prominently displayed in Arnold Drury's window (to the right of the above image) provides a potential answer to the drastic change, it reads: '*Viande Cheval* [horse meat] *is far superior now it is cooled by Frigidaire.*' The picture dates from around 1956; this type of shop would be completely unacceptable to the vast majority of British people today.

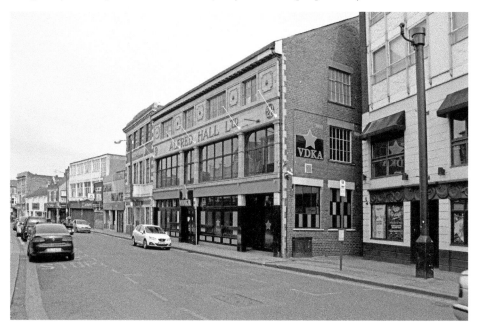

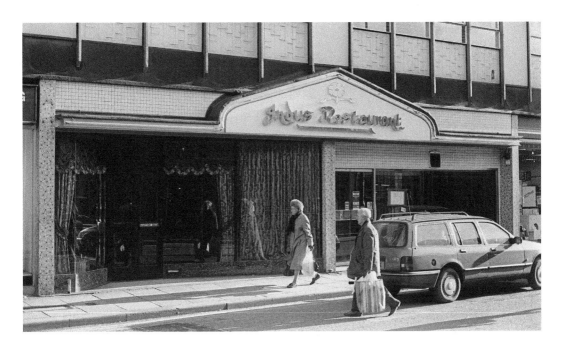

Silver Street

Karim Din established the Indus restaurant in September 1968, a time when fish-and-chip shops were still on many street corners. The premises were enlarged in 1978 to hold around 178 diners. From that time, the restaurant gained an enviable reputation and was frequented by people from many surrounding towns and villages; celebrities like Ian Botham, Freddie Starr and Billy Connolly also enjoyed eating there. Karim's sons, Nayeem and John, helped in the family business until the Indus closed and everyone's efforts were concentrated at the Grand St Leger Hotel, Bennetthorpe. At the time of writing, a new Indus is planned to be incorporated into a very ambitious development at the hotel. The old Silver Street premises are presently occupied by the popular Hogans Bar.

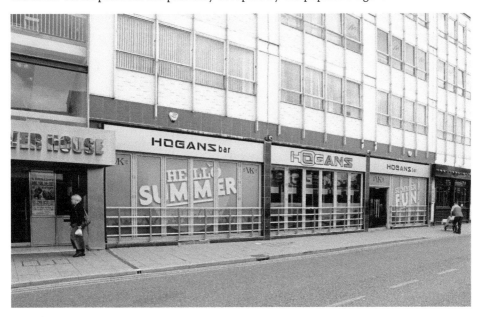

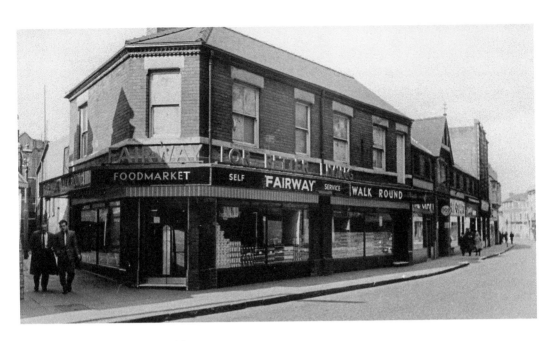

Silver Street/Bower's Fold Corner

Fairway Food Markets was founded in the 1940s by Harry Round. It eventually grew to eight outlets in and around Doncaster, including the one shown above at the corner of Silver Street and Bower's Fold. The property is on the north side of Silver Street, which was set back under the Doncaster Corporation Act of 1904. Later, the Fairway firm was run by Harry's three sons; they sold the business in 1983 for around £1m to the Milton Keynes-based company, Linfood Holdings. At that time Fairway employed around 400 people. The multi-million pound firm, Linfood, owned 250 shops but did not have a Doncaster site. The Silver Street premises were subsequently occupied for a time by a fruit machine and one-armed-bandit arcade. Standing empty for a period, the building is currently in a sorry state and is desperate for a new lease of life, perhaps via demolition and then rebuilding.

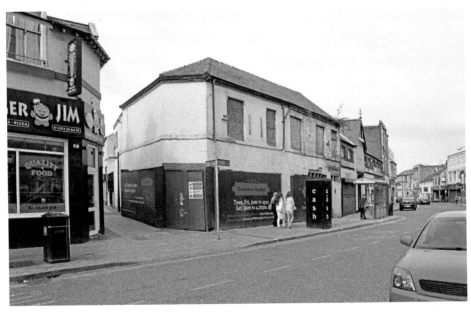

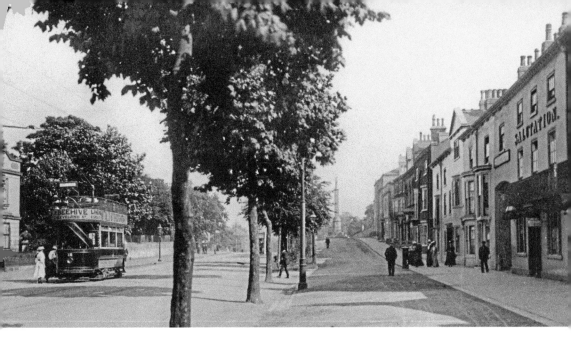

South Parade

Clearly visible and trading in both pictures, is The Salutation public house, dating from at least 1744 but moving to its present position around 1778 and built by Bethune Green. Public transport has moved from the electric trams that began in 1902 before giving way to trolleybuses and motorbuses. On race days, South Parade saw thousands of people on their way to the town's races. Curiously, in the days of trams, a bullion car could be seen passing here carrying all of the receipts from the racecourse back to the town centre. The tram usually had many policemen on board. South Parade is now a conservation area: it has survived relatively unscathed from unsympathetic alterations and additions, unlike many other areas around the town.

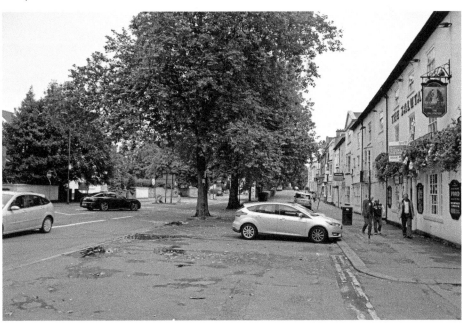

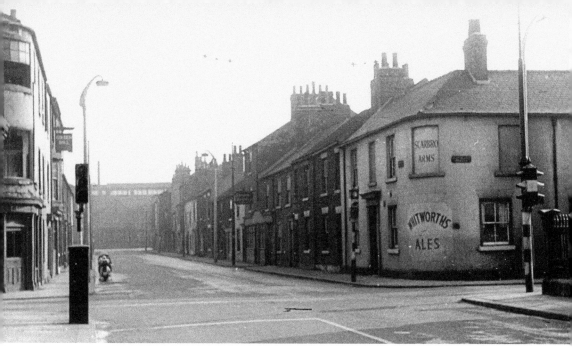

Spring Gardens

Spring Gardens was formerly part of the extensive market gardens that belonged to Mr Jarratt. It was set out from St Sepulchre Gate to Chequer Lane (now Waterdale), by Thomas Bradford during May 1795. The first houses were built in 1796, by 1811 there were forty properties in Spring Gardens with building continuing throughout the remainder of the century. One famous person who lived there for a period was ex-England manager Kevin Keegan. All of the properties in the Cleveland Street to Waterdale section of Spring Gardens (as seen above) were cleared in the early 1960s, this part came within the area that was designated for shopping and business and was later named College Road.

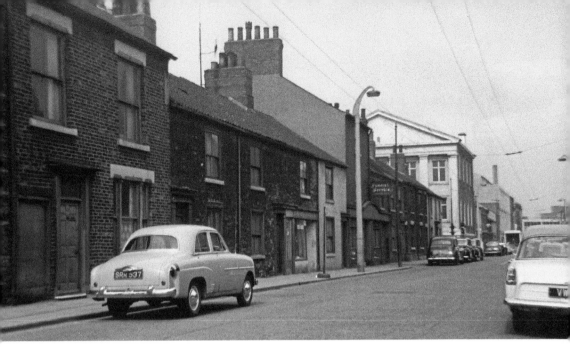

Spring Gardens

No brick remains today from this section of Spring Gardens (looking north from the section of the street seen above), extending between Waterdale and Cleveland Street. The picture was taken near to the Golden Ball (an out of view pub) and looks towards the Scarbrough Arms (which existed from around 1862–1960) and the Spring Gardens Methodist chapel (established 1854 and demolished 1965). Property on both sides of the street was obtained in a Central Area Compulsory Purchase Order to be demolished in the early 1960s. The brutalist-type building on the west side of the street once housed the Southern Bus Station; it was built by Frank Haslam Milan & Co. Ltd at a cost of over £200,000 and opened in July 1966, closing in around 2006. The structure presently provides a car park for the Civic Quarter.

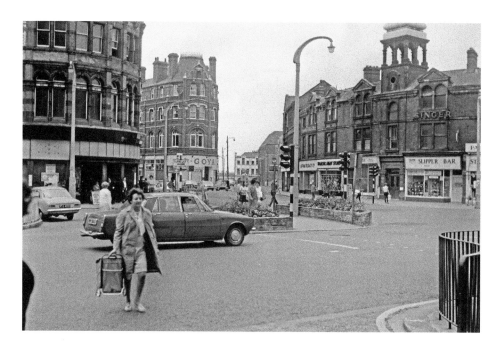

Station Road

Extending from the railway station to St Sepulchre Gate, Station Road was formally opened on 31 August 1882. Once familiar buildings in the top image include (from left to right): the Doncaster Co-operative Society's stores; the Glyn Temperance Hotel (later incorporating Priestnall's cafe); and the Oriental Chambers. All of the buildings were obliterated for the construction of the second phase of the Arndale (now Frenchgate) Shopping Centre. Opinions on this have been divided: some will argue that the town has been robbed of its best Victorian buildings; others may state that the older buildings were falling into disrepair and the town was in desperate need of more shopping areas.

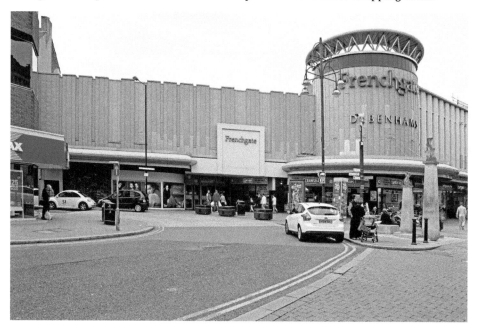

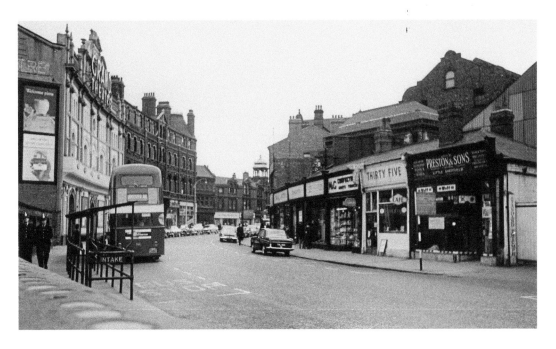

Station Road

The Grand Theatre (seen to left of the image) is the only survivor from the once splendid Victorian Station Road; built by H. Arnold to the designs of J. P. Briggs, the Grand opened in 1899. Throughout the first half of the twentieth century, the premises had a history of switching to-and-fro from theatre to cinema, sometimes including both on its programme. Then in September 1961, the Grand became a bingo hall. The building was given Grade-II listed status in 1994, but was then threatened with demolition. Bingo club operations ceased in 1995 and the building now stands empty awaiting a new use. The 'Friends of the Grand Theatre' organisation continues to fight for its survival.

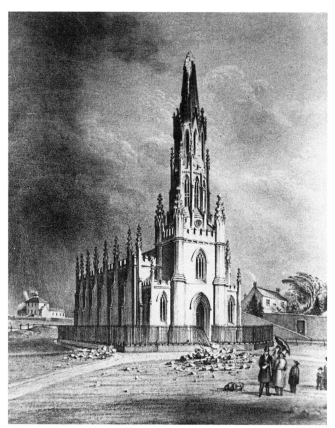

Thorne Road

Built from Roche Abbey stone, in a neo-Gothic design, Christ Church opened on 1 November 1829. The stone spire was shattered by lightening in 1836, as seen above; then later, in 1856, the premises were enlarged according to the designs of Sir George Gilbert Scott. The replaced spire was taken down in 1919, with the church existing without a pinnacle until 1938 when a new one (wooden-framed and copper clad) was erected. Without adequate funds, Christ Church deteriorated to such an extent that by 1989 it was declared to be a redundant church. When acquired by the Reachout Christian Fellowship for £5 in 1994, the building underwent a £1 million refurbishment; in 2004 it opened once more for public worship.

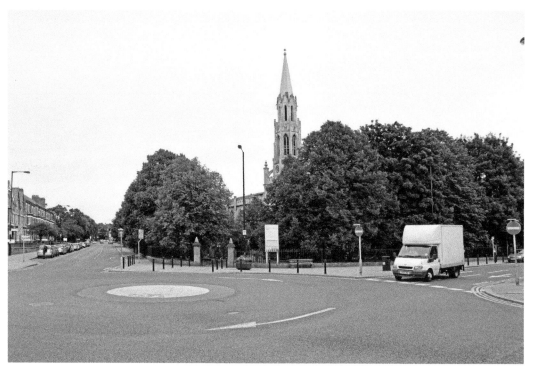

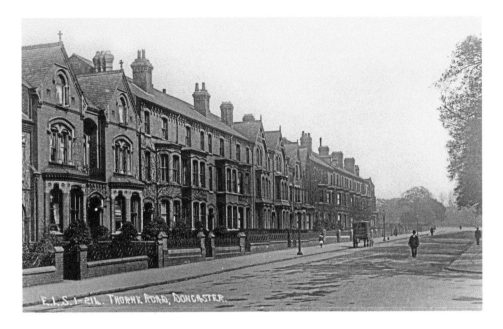

Thorne Road

Depicted in these images is the three-storey red-brick Herschel Terrace (Nos 1–41) on the north side of Thorne Road. It was erected 1881–1891 according to the designs of several architects, including F. W. Masters. Construction coincided with the centenary of Sir William Herschel's discovery of the planet Uranus, because of this the property appropriately took his surname; a further reason was that when Herschel was a young man, he took part in concerts at Nether Hall. Herschel Terrace is not affected too adversely by the commerce that predominates. For the most part, signage is restrained and in many cases the perimeter walls are still extant, even though they no longer surround colourful flower-gardens. The stretch of property is part of the Christ Church conservation area, originally designated in May 1977.

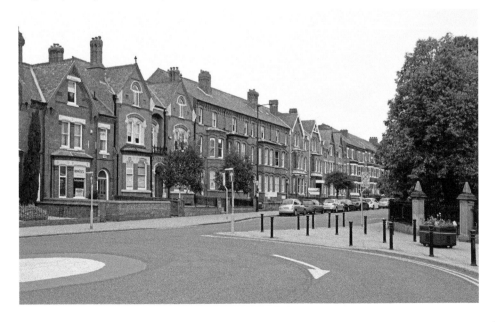

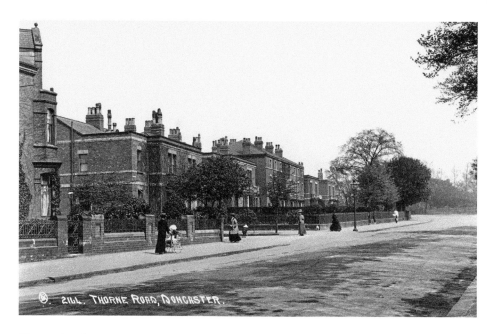

Thorne Road

Thorne Road is depicted here looking eastwards at the junction with Christ Church Road. The stretch of properties beyond the junction (St George's Terrace and Villas) were built in red brick in around 1868, they comprise of a pair of semi-detached dwellings that flank a terrace of four houses. While this line of properties, along with Herschel Terrace, remain largely intact, they have been blighted by the unfortunate reputation attached to the area. Until recently, when a large clean-up operation was mounted by vice police and neighbourhood-watch teams, the area was littered regularly, day and night, with prostitutes, kerb crawlers and drug dealers. Thankfully, with everyone's efforts, the general tone of the area has been raised and the prevailing atmosphere is less intimidating for its residents.

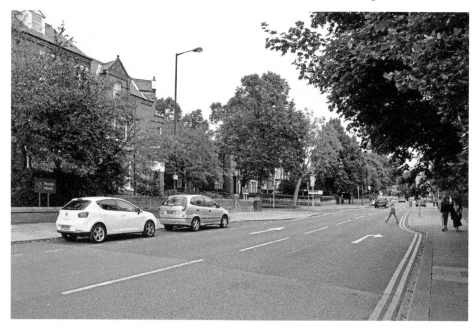

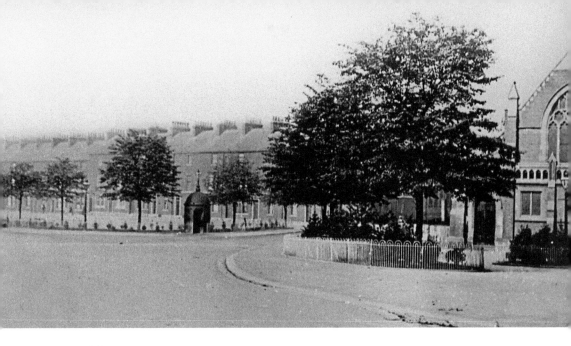

Waterdale

The view in the above image looks over towards the row of two-storey terraced houses (Harwood Terrace) that extends between Young Street and Wood Street, which was built by corn-mill owner Mathias Harwood. The property survived a demolition threat during the early 1960s when an extensive redevelopment of Waterdale was planned but never fully completed. Today, much of the terrace is occupied by a furnishers, Ward Bros; the company took root there around 1930, at No. 32, and gradually took over property Nos 29–40. The area in-front of the terrace was used as a bus station from around the early 1920s, but was moved to Glasgow Paddocks (above, out of view to the left) during the Second World War. The row of lime trees was a gift from John Walbanke Childers of Cantley Hall in 1864.

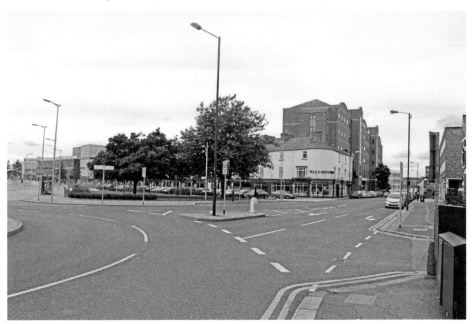

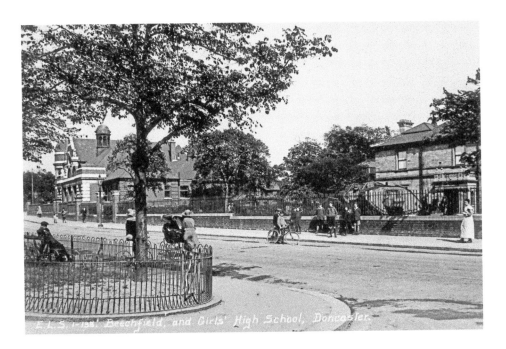

F.L.S. 1-138. Beechfield, and Girls' High School, Doncaster.

Waterdale

Above are two well-known Waterdale buildings: Beechfield House (to the right) and the Municipal High School for Girls (to the left). Beechfield House, built around 1812, was the town's museum and art gallery between 1909 and 1963. The house and grounds were cleared in 1963 for the building of the new technical college, which itself was demolished in 2009 for the construction of the new Council Civic Office (seen below). Designed by the architect Cartwright Pickard, this building now forms part of the town's Civic Quarter. The Municipal High School for Girls was built in 1910 according to the designs of J. M. Bottomley and G. T. Welburn of Leeds; it was extended in subsequent years. The premises were partially demolished in 2014 and the whole site currently awaits further redevelopment.

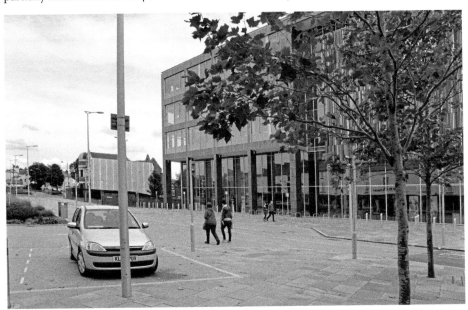

Waterdale

In the above image, the properties on the north side of Waterdale stretch between Cartwright Street and Young Street. The buildings to the left were along the section between Baker Street and Cartwright Street. None of the properties appear on a map dated to 1767. From the 1820s house-building in Doncaster town centre gathered momentum, it expanded beyond the bar-dyke, swamping gardens and fields. An 1852 OS map shows all the buildings seen above in existence at this time. During the immediate post-war years, Waterdale provided a convenient route for motorised traffic travelling east-west through the town. Thus, it was perhaps inevitable that dwellings would be converted for commercial use. It cannot be denied that the properties look dilapidated; after existing for over 100 years the area they covered was absorbed by the Golden Acres and Civic Centre schemes during the early 1960s.

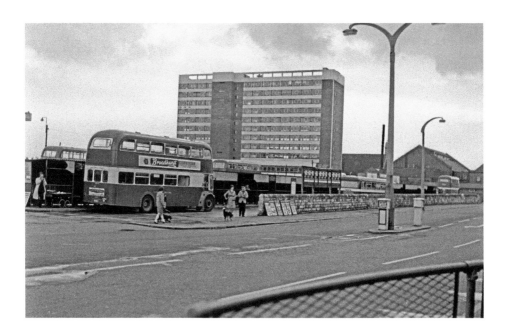

Waterdale

The top image faces the Glasgow Paddocks bus station, NCB tower block, and Baths; it dates from the mid-1960s. This is when the area was considered for forming part of a civic quarter that would include the following: a central building for council services, a theatre, central library, police station, court house and a technical college. The bus station was vacated later in the decade and for many years afterwards the area was a car park leaving this entire stretch of Waterdale with an unfinished and untidy look. This predicament was highlighted on a number of occasions by Eric Braim in *Civic Trust Newsletters*. Finally, in recent years the situation has been drastically altered through clearance and rebuilding schemes that have enabled the area to be properly titled Doncaster's Civic Quarter.

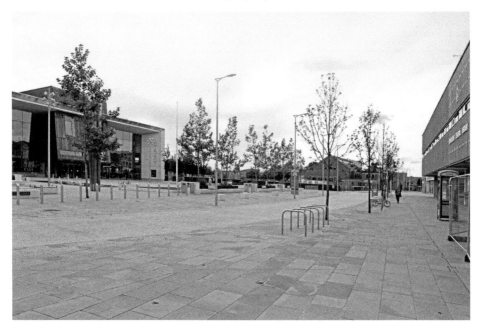

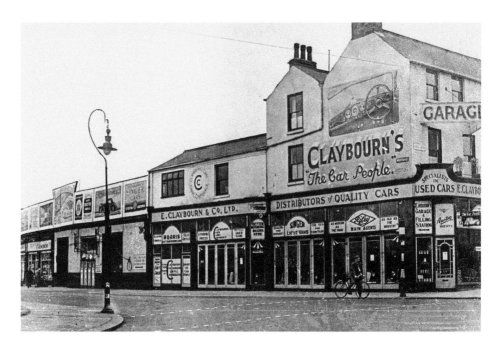

Waterdale

Initially, Ernest Claybourn (born in 1893) established a motor-garage on Askern's Doncaster Road in 1922. The business grew and in 1931 he moved to Waterdale. His small show-room originally held four vehicles, though it expanded into most of the other buildings. After enjoying the boom years in the motor car industry for much of the twentieth century, a great upheaval took place in 1970; there was a change in the company's management structure, a reduction in the range of cars sold, and part of the business was transferred to a different location. Clayborn's sales department was moved from Waterdale to Prince's Street in around 1970, but was eventually relocated to Balby Bridge. Some of the old Waterdale structures were demolished in 1971 for a new office block. The remainder have continued to exist as commercial premises and are currently occupied by the Bed Shop, which according to the website, has been operating for over forty years. Claybourns ceased trading in 1987.

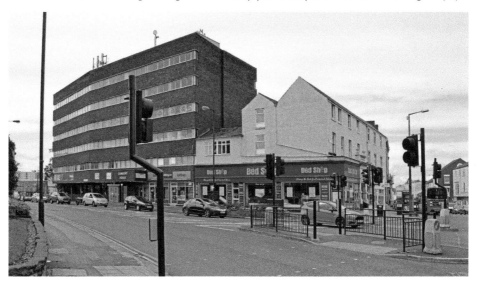

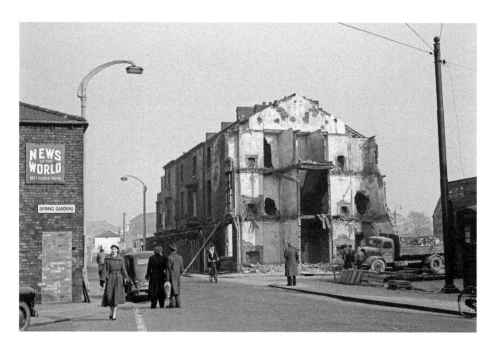

Waterdale/Spring Gardens Junction

A map from 1767 shows Waterdale as an open road amid fields and gardens. By the turn of the eighteenth century it had become a rubbish dump, but in the following years it was cleared for the sale of horses, becoming known for a period as Horsefair. Around 1816 house-building began; the three-storey terraced houses shown above probably date from that time. As more properties were erected in subsequent years, Waterdale became a residential area where some occupants boasted having their own servants. An OS map of 1852 shows the terraced houses in existence and with extensive gardens to the rear. The top image was taken in the late 1950s; many such properties, that were sadly lacking modern facilities, were later cleared. Ultimately, this left Waterdale with no houses and set the stage for the Civic Quarter scheme to gather momentum.

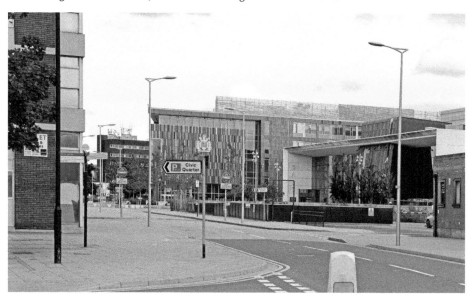

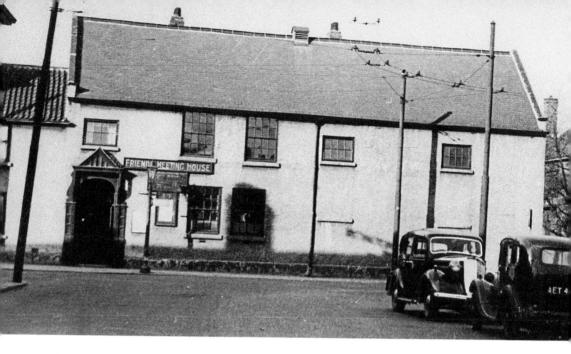

West Street

A Friends' meeting house was built at Warmsworth by Thomas Aldam in 1706 with an adjoining burial ground. The Friends remained there until 1798 when they moved to a converted barn in West Laith Gate, seen above. Local builder Thomas Anelay carried out the conversion work on the building, which could accommodate around 200 people. It also comprised of a main hall and caretaker's cottage. In later years the premises were used as an education centre, which was demolished in 1976. The building seen below on the former meeting house site forms part of Trafford Court, erected in around 1990.

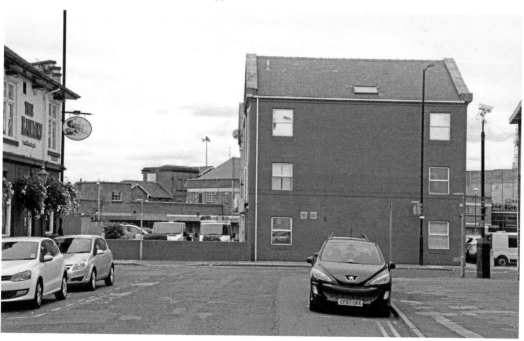

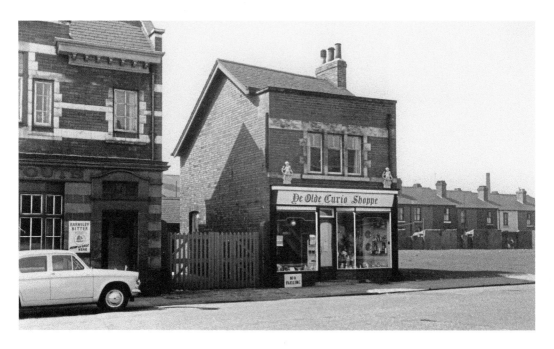

West Street

Jack Green started an antique business just after the Second World War, using a gratuity he received for his service as a flight engineer in the RAF. He first had a shop in St Sepulchre Gate, then moved to premises in West Street around 1965. On 2 December 1975, Jack was found dead in the shop where he also lived. He had died from carbon monoxide poisoning after the flue at the back of his gas fire had become blocked by soot. Later occupants of the premises were TAG (Transport and General) models and books, run by Andrew Fisher and Chris Palmer. During the intervening years the GPO sorting office was erected on the land adjacent, but is now empty while the site awaits redevelopment; hopefully this will be imminent.

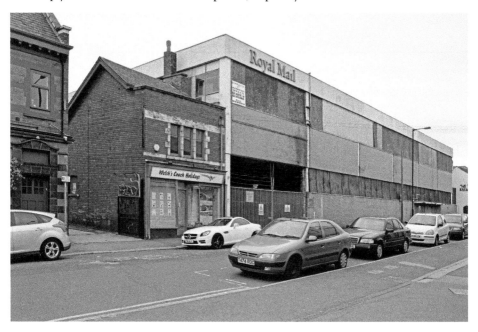

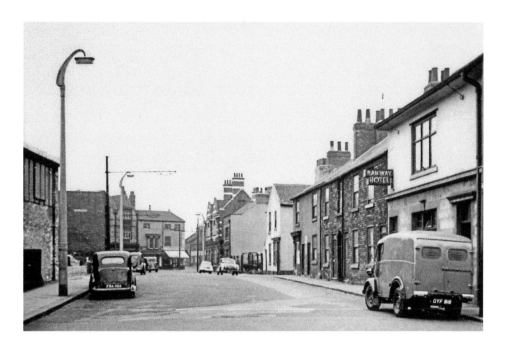

West Street

West Street (facing south) with the Railway Hotel visible to the right in both pictures. Electric trams that worked on the Balby and Hexthorpe routes did not travel from the town centre via West Laith Gate and West Street to reach St Sepulchre Gate, although trolleybuses did when they operated; in fact West Street is still on a public transport route today. The main area of change during the intervening years has been the removal of the dwellings on the western side, which date to around the mid-1850s. In fact, the Railway Hotel can trace its origins to at least 1853 and was probably built around the same time as the adjoining properties. At one time an alley on the left led to Moore Place, and one on the right to St Peter's Square.

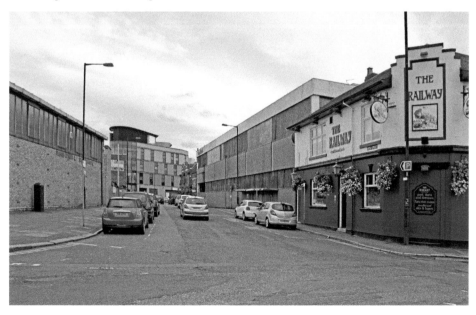

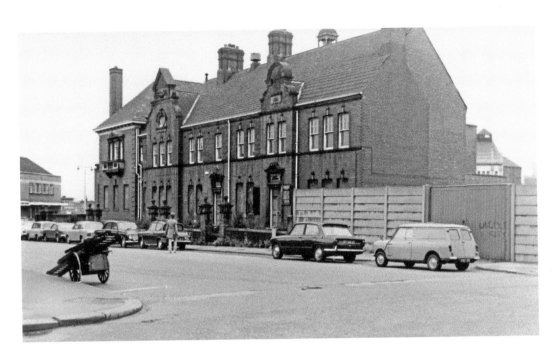

West Street/Trafford Court

The building in the top picture has a date-stone of 1890, at one time it accommodated the West Riding Court House County Constabulary Divisional Headquarters, which opened in March 1891. The premises were extended in 1930 and later became known as Crown Mills House when they were occupied the DMBC Planning Department. During the 1980s the building was demolished and replaced by the one seen below. Although not as impressive as the previous edifice, the new one was applauded, if only for the return to a building with bricks and the inclusion of a pitched and tiled roof.

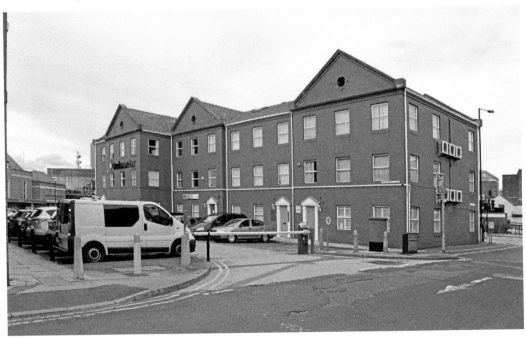

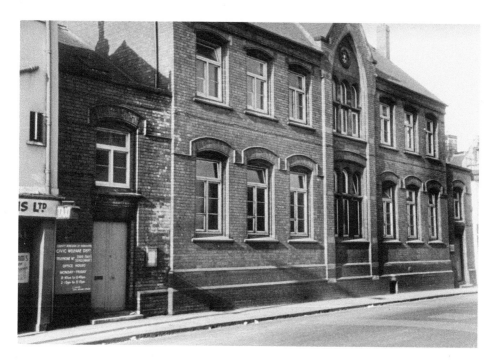

Wood Street

Doncaster's first British School was opened – initially just for girls – in Hallgate on 1 June 1832. On 12 April 1835 the school moved to new premises that were built in Wood Street (seen above), at this point it was now for both boys and girls. The building was extended in 1846, 1872 and 1877, but ceased to be used as a school in 1926. Thereafter, the property became the Public Health Offices, the Civic Welfare Offices, and in 1972 was partly used as the Borough Treasurer's Rate Collection Department. The site was swallowed up during the 1990s for the construction of the sprawling DHSS complex.

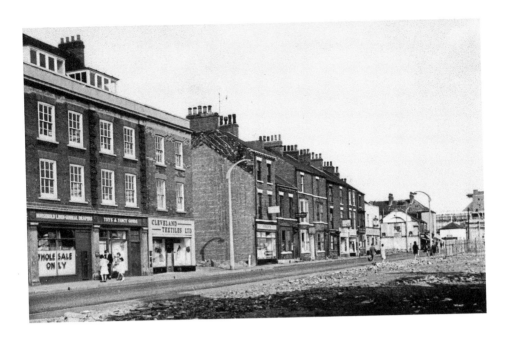

Young Street

The Golden Acres development (more familiarly known as the Waterdale Shopping Centre) covered land bounded by Spring Gardens, Waterdale, Young Street and Cleveland Street. Demolition occurred in and on the area's periphery. As can be seen below, Young Street is now truncated as a result of the development; it has arguably been left with an untidy appearance. The 1961 Doncaster directory gives a good picture of the street's makeup before the Golden Acres scheme was undertaken shortly afterwards. According to this, there were fifty properties and around half were occupied by a variety of business people, including: estate agents, drapers, painting contractors, fruiters, a commission agent, and a florist. The remainder of the houses (some of which comprised of three storeys) were tenanted by private individuals. Curiously, the Staff of Life public house was rebuilt only a few yards from its original position on the street.

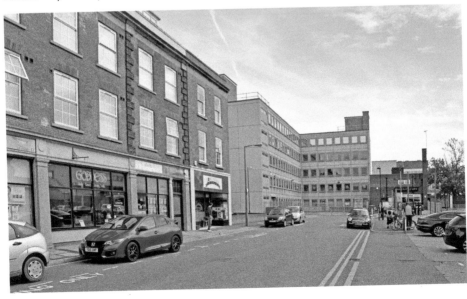